THE WOODBLOCK ENGRAVERS

Rescue at sea. A late nineteenth-century news picture

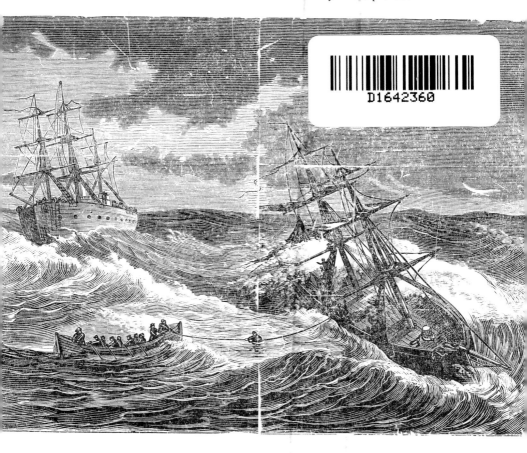

The Woodblock Engravers

KENNETH LINDLEY

DAVID & CHARLES : NEWTON ABBOT

7153 4793 4

(The illustration on the title page
is by Kenneth Lindley)

Set in 10 on 12pt Pilgrim
Printed in Great Britain
by W. J. Holman Limited Dawlish
on Foxhunter Twinwire Superwhite Smooth Cartridge
supplied by Robert Horne Paper Company Limited Bristol
Bound in Medallion Glindura
by Adams & Harrison Limited Biggleswade
for David & Charles (Publishers) Limited Newton Abbot

Contents

To S. T. Lawrence, Blockmaker,
for more than twenty years of encouragement
and for much of the material from which this
book is compiled

The pre-history of wood engraving

THE nineteenth century was the golden age of the craft of wood engraving. The woodblock was transformed by Thomas Bewick (1753-1828) from a method of illustrating cheap printing to a medium worthy of a place among the highest achievements of printmaking. By the end of the century wood engraving had become an essential medium for all kinds of printed illustration, from encyclopaedias to illustrated news-papers, and the master engraver occupied an established place in society, well above that of the humbler compositors, machine minders and journeymen of the printing trade.

Internationally famous artists and illustrators relied on the engraver to interpret (and, it must be said, sometimes improve) their drawings for illustration and thus make them available to a wide and increasingly literate public. In addition to the vastly increased amount of reading matter required to supply the railway bookstalls the printer was called upon to supply industry with catalogues for mass-produced goods and, prior to the invention of the photographic blockmaking processes, only the engraver could produce the necessary detailed and accurate illustrations.

By the latter quarter of the century coloured engravings, printed from several individually cut blocks, rivalled lithography in their

Title page for a cheap book or pamphlet. Early or mid-nineteenth century

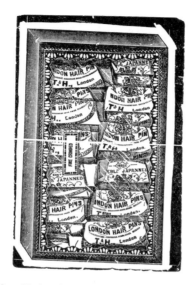

London Hair Pins. A commercial engraving,
probably for a catalogue

accuracy and brilliance. Within a few years of the introduction of photographic techniques to printing the need for craftsman engravers had ceased to exist, and the output of 'trade blocks' dwindled rapidly. However, very soon a revival occurred, not of trade engraving but of wood engravings produced by artists working on their own blocks and this, plus the very few surviving trade establishments, has kept the craft alive to the present day. Even now the popular demand for prints is largely satisfied by the larger and more colourful lithographic or silk-screen designs, and few book publishers are willing to commission engraved book illustrations when line drawings are so much quicker and cheaper to produce.

By Appointment to H.R.H. The Prince of Wales.

ALLEN'S PORTMANTEAUS

37, WEST STRAND, LONDON, W.C.

ILLUSTRATED CATALOGUES of 500 ARTICLES Post Free.

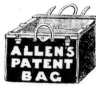
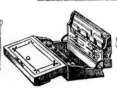
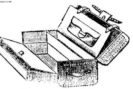

| ALLEN'S PATENT BAG. | ALLEN'S PATENT DESPATCH-BOX DESK. | ALLEN'S PATENT Quadruple Portmanteau. |

SOLID LEATHER DRESSING-CASE. ALLEN'S NEW DRESSING BAG. RAILWAY PORTMANTEAU.

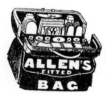
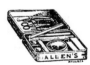
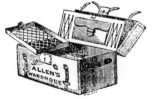

ALLEN'S DRESSING BAG. ALLEN'S SOLID MAHOGANY DRESSING-CASE. LADY'S WARDROBE PORTMANTEAU.

ALSO

Allen's Barrack Furniture Catalogue, for Officers joining, Post Free.

PRIZE MEDAL AWARDED, 1862,

FOR GENERAL EXCELLENCE.

Allen's Portmanteaus. A page from the advertisement section of a Murray's Guide, 1869. Engraved illustrations and heading

The unique qualities of the engraved block will always make their appeal to a discerning few, and the immensely satisfying experience of engraving will always attract some artists, but it would be foolish to suggest that either the technical quality or the quantity of nineteenth-century wood engraving will ever be matched again. Of this vast output little has survived in the form of blocks. Old books, advertisements, broadsheets, periodicals and catalogues are packed with prints, but most of these will disappear before they become 'collectors' items' and thus command respect—and a higher price. Most of the blocks themselves have long since been burnt or mutilated, although it is still possible to come across them, unwittingly preserved by some of the small old-established jobbing printers who seldom throw out anything unless they need the space which it occupies. It is with such blocks, salvaged or borrowed, randomly surviving, that this book is mainly concerned and with which it is largely illustrated, for they are the typical rather than the outstanding examples of the craft and, as such, excellent indications of the variety of use and subject and of the consistently high standards of craftsmanship.

A crude 'white-line' engraving from the stock-in-trade of a Newcastle printer

Primitive but attractive 'white-line' engravings used in a variety of situations

A comparison between the work of one of the best craftsman-engravers of the nineteenth century (the brothers Dalziel, for example, or Edmund Evans) and that pre-dating Thomas Bewick will immediately reveal the extent of the advances made during the nineteenth century. The reasons for this are partly due to the developments in the whole

12

craft of printing and the design of printing machinery and also, to an equal or probably larger extent, to a fundamental change in the production of the block itself. This was the change from woodcutting to wood engraving and the use of boxwood instead of softer woods such as pear.

It is this which made possible the incredibly fine and accurate engraved work typical of nineteenth-century illustration which contrasts so strikingly with the bold, broad work of earlier centuries, and Bewick was the first man to realise and exploit this fundamental difference in quality. It was fortunate indeed that Bewick was not only a craftsman of immense skill but also an acute observer and shrewd interpreter of the world in which he lived. Without Bewick there can be no doubt that the technical demands of a growing industrial society would have led to the commercial exploitation of the boxwood block for printing, but it is doubtful if the standards would ever have been so high, and certain that the history of English illustration in this century and the last would have taken a different path.

The use of wood as a means of transferring impressions from one surface to another goes back beyond the tenth century. The earliest known examples of printing from woodblocks are patterns printed on to textiles—a method still employed for hand-printing today. The Chinese are said to have been the first to produce individual blocks for printing on to paper; the development of woodblock illustration in the West dates from the fifteenth century, a few years prior to the introduction of printing from movable types. The actual method is simple and straightforward and is almost the same as lino-cutting, its contemporary equivalent. A plank of soft wood is first made perfectly smooth and the background of the design which is to be printed is then cut away below the surface, leaving the design itself in relief.

Methods of inking vary slightly. Most contemporary artists and printers use a roller to transfer the ink to the block, but many earlier printers used a dabber. This latter was a leather-covered, wooden object, slightly convex at the base, which was rocked first over the ink and then over the block. The earliest method of printing was that of placing the block face-down on to the surface to receive the impression, and

Illustrations to popular stories (eg Lady Godiva), in the chapbook tradition

hammering the back. This is still the method used for textile printing by hand although it presents obvious difficulties in registration and the block tends to shift slightly.

The other method, which led on to the development of the whole range of letterpress printing machinery, is to place the block with the inked surface uppermost and lay the paper over it. The paper can then be burnished by hand or pressed downwards by machine. Even before the invention of printing from movable type, woodblocks were being used to produce quantities of single sheets in this way (one of the earliest examples of mechanised mass-production). These sheets usually showed a picture drawn in thick lines, with a line or two of text beneath, and their most common use was probably for sale to pilgrims who wished—then as now—to take home a souvenir of their journey. Being comparatively cheap they were regarded as expendable and those which survive today are consequently extremely rare and valuable.

As soon as printers were able to set type from individually cast letters, independently of the woodcut illustrations, the use of the woodblock changed. Most printers would carry a stock of woodcut illustrations and decorations, which they used in a somewhat random fashion to enliven the pages of their books or their broadsheets. The same illustration might thus crop up in a Bible or in a Latin grammar, little attempt being made generally to match text and picture in any but the vaguest manner.

In spite of such humble and inauspicious beginnings the craft of the woodcutter became established alongside the more ancient trades such as the goldsmith's and was, at least on the Continent, very highly esteemed. Even an artist of the stature of Dürer was proud of his membership of the Guild, and almost certainly cut the blocks for his great series of illustrations. The early history and development of the woodcut has been very fully investigated and documented, and even the few remaining examples provide ample evidence of a fairly rapid rise from a crude method of producing such ephemera as playing cards and tracts to a medium worthy of the attentions of artists as important as Dürer and Holbein. It was, however, ousted from its place as an acceptable form of printmaking and illustration in sophisticated con-

texts by the rise of intaglio printing from metal plates.

The latter method allowed the artist much greater flexibility and fineness and it dominated both book illustration and artists' print-making throughout the seventeenth and eighteenth centuries. Intaglio printing from metal plates is an exquisite but costly and time-consuming method. It suited ideally the sumptuous volumes issued on subscription to educated gentlemen and patrons of the arts and sciences in the eighteenth century. It was, in its turn, overtaken by wood engraving and lithography in the last century, both of these methods being

Crude but effective illustrations for chapbooks or similar cheap printed matter

Two further examples of illustrations in the traditional manner

capable of high-speed quantity production at a fraction of the cost of intaglio printing. They also allowed colour to be introduced into cheap printing, virtually for the first time. Previously, if colour was required it had to be 'tinted in' by hand. Both wood engraving and lithography used a number of blocks (or stones) to print different colours, each superimposed on the others.

By the middle of the eighteenth century the woodcut had declined

17

B

top: *A typical 'black-line' cut in
which a pen drawing has been
reproduced in facsimile*
right: *An illustration equally
crude in drawing, but using a
combination of white and black
line*

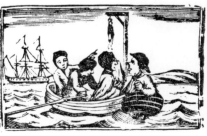

Two 'black-line' engravings

19

into a cheap method of producing illustrations to printed matter of various kinds. These illustrations were usually crudely drawn and cut and often carelessly printed. They were produced in workshops spread throughout the country, serving the needs of local printers. Like their earliest predecessors they often had to serve many different purposes and in this way they anticipated the 'stock blocks' which have been a feature of typefounders' catalogues for nearly two hundred years.

Eighteenth-century woodcut illustrations are, at best, good examples of popular art and they should be seen and enjoyed in the same way as the carvings on rural tombstones and ships' figureheads. They persisted, of course, long after Bewick had demonstrated the superior qualities of the wood engraving and, like wood engraving, they have been subject to revival and rediscovery in more recent times. They cannot, however, rival the engraving and their attraction is usually that of naivety, whereas that of the engraving is its sophistication. A naive engraving is seldom an attractive thing.

Although boxwood had been used prior to Bewick's time, the essential difference between it and the softwood blocks had not been properly understood. Whereas the grain on a softwood block runs horizontally through it the boxwood block is cut with the grain running vertically (ie as a horizontal section of the tree). A block for wood-cutting is referred to as being 'on the plank'. The fine, close, even grain of the box thus allows for very fine engraving, every part of the design left in relief being supported by a continuous fibre of the wood running through the total depth of the block .

Bewick did two things: he recognised this quality of the wood which enabled work to be produced which was as fine as anything which the metal engravers could do, and he also realised the potential of the direct use of the engraving tools as opposed to the slavish copying of drawings done onto the block. Bewick drew his own designs on to the block, but he interpreted them in terms of the marks made by the tools themselves. It is this, combined with his own considerable talent as an artist, which makes his work so attractive as well as so significant in the development of the techniques of illustration and engraving.

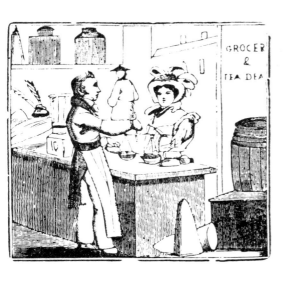

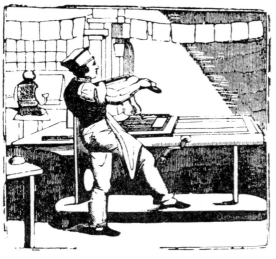

Two of a series illustrating various trades, from the stock of a Newcastle printer. Probably early nineteenth century

Three prints in decorative borders
left: *a story or fable;* bottom left:
a hunt; bottom right: *a printer in*
his composing room

22

Further prints within decorative borders

Thomas Bewick and his time

THOMAS Bewick had the rare good fortune to have been appreciated, and reasonably prosperous, in his own lifetime. He spent most of his life in Newcastle, a city which has produced a number of other eminent engravers. The Newcastle City Library possesses a very fine collection of Bewick's blocks, proofs and other materials (although the manner in which they have been treated leaves a great deal to be desired). The importance of Newcastle in the history of wood engraving is an interesting illustration of the way in which printing and its attendant industries have always been spread geographically.

At one point in his career Bewick was tempted to try his fortune in the capital but he was very unhappy there and returned to his native city with relief. Bewick not only wrote and illustrated, but also published his own books from Newcastle, and it is as a result of these books that he is so widely remembered. What is not so often appreciated is that he also executed a mass of work for use in jobbing printing, much of which must have vanished for ever.

As he became more successful he naturally enlarged his business to take on apprentices and other journeymen, and it is often impossible to tell for certain which of the later prints are engraved by Bewick himself and which were the products of his best workmen. Thus the

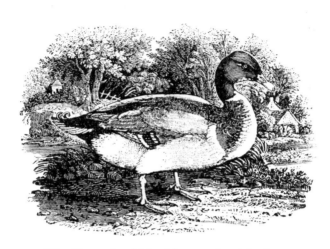

'The Tame Duck' by Thomas Bewick, from
British Birds *volume 2*

Bewick establishment, although distinguished by the presence of the proprietor, followed the same pattern as any other firm of trade engravers, undertaking all kinds of work for all manner of customers.

Bewick served his apprenticeship under a jobbing engraver named Ralph Beilby, with whom he later went into partnership. He was articled in 1767 at a time when woodblocks were mostly associated with the cheap and often crude 'chapbooks', hawked about the country by itinerant traders known as 'chapmen'. The work undertaken in the Beilby workshop was described by Bewick in his *Memoir* (published after his death, in 1862) and he gives a very good impression of the life of the engraver in the mid-eighteenth century.

*An early primitive 'black-line' print which illustrates
the tremendous advances both in design and
technique made by Bewick*

The craft of engraving originated with the metalworkers who used it to decorate their products, and the tradition was still alive in the mid-eighteenth century. Printing blocks were only a part of the work brought into the Beilby shop and all manner of other jobs were undertaken. After describing some of his earliest tasks, including copying 'Copeland's Ornaments', 'blocking-out the wood about the lines on the diagrams (which my master finished) for the "Ladies Diary"', and 'etching sword blades for William and Nicholas Oley, sword manufacturers &c., at Shotley Bridge', Bewick goes on to describe the work of his master.

26

After these, I was kept closely employed upon a variety of other jobs; for such was the industry of my master that he refused nothing, coarse or fine. He undertook everything, which he did in the best way he could. He fitted-up and tempered his own tools, and adapted them to every purpose, and taught me to do the same. This readiness brought him in an overflow of work, and the work-place was filled with the coarsest kind of steel stamps, pipe moulds, bottle moulds, brass clock faces, door plates, coffin plates, bookbinders letters and stamps, steel, silver, and gold seals, mourning rings, &c. He also undertook the engraving of arms, crests and cyphers, on silver, and every kind of job from the silversmiths; also engraving bills of exchange, bank notes, invoices, account heads, and cards.

In later years, although achieving wide recognition as an illustrator (Audubon went out of his way to meet the ageing Bewick), Thomas himself undertook a similar variety of work and displayed interests in many current national and local affairs. An interesting sidelight on Bewick and his times occurs elsewhere in the *Memoir* when, after listing various books for which he had provided the blocks, he describes another job which had come into the workshop.

My partner and self were busily engaged in engraving, about the year 1796, the plan of the proposed canal from Newcastle to Carlisle, as projected by Mr Chapman, engineer, and plans of estates and views of the mansion houses of a few gentlemen who opposed the canal, on the north side of the Tyne.

He then cannot resist expressing his own views on the affair.

After a great deal of scheming and manoeuvering, under the management of an attorney of great ability, the whole of this important national as well as local undertaking was baffled and set aside. Most men of discernment were of the opinion that the coalowners 'below bridge' were the cause of it . . . and in this, as in almost every other case, private interest was found to overpower public good.

This varied work must have been the mainstay of the workshop for many years for, as has already been stated, woodcuts and engravings were very much the poor relation of metal plates for book illustration. This was due in part to the generally crude levels to which the craft had descended and due also to the poor standard of presswork available from printers using the blocks. These two factors had combined to

27

blind both printers and engravers to the possibilities of the woodblock in a field where the copperplate was regarded as supreme.

Even after Bewick had recognised the possibilities for the development of the woodblock he was compelled to undertake a number of technical experiments in order to ensure that the printed result bore a reasonable resemblance to the engraved design. When he first started out on his career he had no idea that the woodblock could ever rival the copperplate, and Beilby even took a trip to London to learn the craft of etching in the (unrealised) hope that he might thus attract more refined work to his business.

However, as soon as it became apparent to Bewick that wood engraving could be as fine as metal engraving for printing, his enthusiasm knew no bounds. He says: 'The more I have since thought upon the subject, the more I am confirmed in the opinions I have entertained, that the use of woodcuts will know no end, or, so long as the importance of printing is duly appreciated and the liberty of the press held sacred'. The phraseology has a nice period ring about it, and Bewick's vision was to prove remarkably accurate.

It was, of course, Bewick's character and outlook as much as his skill as an engraver which enabled him so to raise the level of wood engraving as to transform not only the craft itself but also printed illustration, and to influence both; an influence which remained long after Bewick's death. Like many great men the source of his strength and his inspiration lay in his ability to observe and to respond to his own immediate environment. As he himself puts it: 'I ought also to observe that no vain notions of my arriving at any eminence ever passed through my mind, and that the sole stimulant with me was the pleasure I derived from imitating natural objects (and I had no other patterns to go by), and the opportunity it afforded me of making and drawing my designs on the wood, as the only way I had in my power of giving vent to a strong propensity to gratify my feelings in this way'.

Bewick's greatest works, and those which established his place both in the history of the minor arts and in the world of the naturalist, were undoubtedly the two volumes of *British Birds*, the first of which was first published in 1797. It proved immensely, and justifiably,

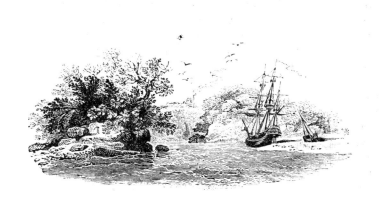

Sailing vessels in a cove, with a distant view of a smoking chimney. A tailpiece from Bewick's British Birds

popular and went into many subsequent editions, all printed from the original blocks. The original price was thirteen shillings and, because of the large number subsequently printed, it is still possible to obtain copies of later editions for little more than the original price.

The two volumes, of *Land Birds* and *Water Birds*, are among the most delightful books ever published and they set a standard for illustration which has never been excelled and seldom equalled. Not only is the observation and attention to detail and the engraving of the blocks of the highest possible standard, but the sense of rightness with which each is placed on the page and the balance between text and illustration comes as near perfection as any printed book is likely to attain. They revealed the hitherto unexploited possibilities of the woodblock and enabled the letterpress printer once more to think in terms of books equal to those with copperplate illustrations. They also opened the door to a flood of cheap illustrated printed matter which was to grow in increasing volume throughout the nineteenth century and which continues unabated to the present.

Bewick had earlier produced and published *A General History of Quadrupeds*, a labour of love worked on largely in his spare time, and this was far better than anything previously engraved on wood, but it was the *Birds* which were to be his greatest achievement. Practically every illustration was originally drawn from nature—in itself a considerable feat—and the British Museum possesses some delightful original drawings in water-colour. Few other artists have ever managed to combine such accuracy of detail with the quality of a living creature with such success.

Every bird is drawn in its natural habitat, and they never look (as do so many lesser ornithological illustrations) like stuffed specimens in a museum case. Sometimes the backgrounds were taken from scenes known to Bewick but it was not so much in these as in the vignetted tailpieces which fill every vacant space that Bewick gave full flight to his passion for recording nature and his fellow men. If the *Birds* mark

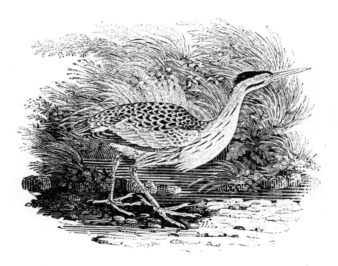

'The Female Little Bittern', from Bewick's
British Birds

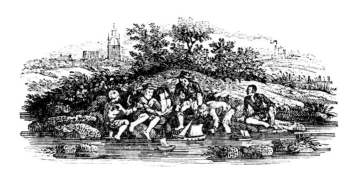

Vignette from the title page of Bewick's British Birds,
volume 2 (Water Birds)

the beginning of a new era in natural history recording, the tailpieces
are an open window on the daily life and landscape of the late eight-
eenth century in northern England. Although local in content they
present a microcosmic view of the whole human condition. Bewick
was, in fact, one of the first English artists to record the ordinary activi-
ties of ordinary people and he did it with a sympathy and kindly wit
which brings them to life even after the lapse of nearly two centuries.

The content of these vignettes has been insufficiently examined or
commented upon, for they include truthful representations of a vast
range of scenes and activities uncoloured by the heroics of popular
romanticism. Smoking mill chimneys, collieries, merchant ships, load-
ing staithes, horse tramways, occur alongside the more obviously rural
scenes, and the title pages to both volumes have views across the
countryside with distant chimneys sending smoke across the landscape.
This is no townsman's view of idealised pastoral pleasances but
eighteenth-century provincial life complete with its grime, its poverty,
its cruelties—and its pleasures. Had Bewick done nothing else he would

have provided in these vignettes one of the most fascinating and complete sources for the social historian ever left for future generations.

The vignette which precedes the 'Little Bittern' on page 26 of the *Water Birds* is a fine example. It shows a barge and a two-masted sailing vessel being loaded with coal from a raised pier or 'staithe' along which some coal trucks are being hauled by a horse. From the top of this openwork structure the coal is being poured down chutes and at the end of the platform is a pulley for raising the chute out of the hold of the vessel when loading is completed. A couple of figures —a man with a walking-stick, and a boy—stand on the barge, a rowing-boat pulls away across the river, and in the background are the masts and rigging of more ships. Also in the background are some houses, a tall building with a factory chimney pouring out smoke, and a smoking beehive-shaped furnace. All this, depicted on a block measuring 1½ x 2½ in, is tainted with none of the 'Lord's Prayer on the head of a pin' virtuosity for its own sake which characterises so much small-scale work.

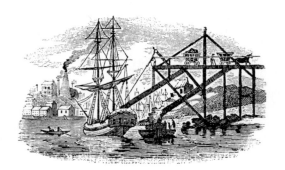

Tailpiece by Bewick from British Birds *showing an industrial scene, probably on the Tyne*

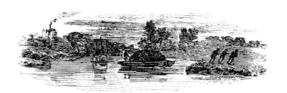

A tailpiece of a river scene from Bewick's British Birds

An even smaller print (less than 1 x 2½ in) on page 78 of the same book shows a loaded barge being bow-hauled by three men whilst another man stands in the stern with a pole. Bewick manages to fit into this diminutive picture a small sailing boat, another staithe, a mill, and a rural landscape of trees, fields and hedges.

Many of these vignettes have become well known because of constant reproduction, and the typefounding firm of Stephenson, Blake Ltd of Sheffield still offer electros of a selection in their catalogues, but there are hundreds of them in Bewick's various books covering every imaginable aspect of life. Human foibles are treated with a slightly disapproving amusement (a drunk sees two moons as he crosses the fields on his way home); small incidents are used to show the richness and variety of human character. Compassion is shown in such prints as that of an old horse 'waiting for death', a version of which Bewick dedicated to the Society for the Prevention of Cruelty to Animals. Bewick's observation is shrewd, his concern real and unsentimental. Like all the great observers of life Bewick was able to use the most delightful methods of recording and commenting upon his experiences.

He foresaw the future uses of wood engraving and he initiated many of the technical innovations which were to be so cleverly used by his successors. As a means, first of all, of overcoming bad presswork, he lowered the surface of sections of his blocks which he wanted to print lighter than their surroundings (eg some of the backgrounds). This requires great skill. He also described how he lowered the edges of the engraving to prevent or to minimise the effects of excessive pressure in printing, which squeezes ink to the edge and thus darkens it.

33

C

Woodblocks stand up to extremely hard wear if treated reasonably well and Bewick knew how to strike a balance between fine engraving and mediocre presswork to achieve his ends. One of his blocks, supplied to a local newspaper, was known to have produced nearly a million impressions in his lifetime and it was still in use with little sign of wear when the calculation was made. Early on, Bewick experimented with printing from more than one block. His original aim was to print cross-hatching by using over-printed lines rather than by the laborious method of cutting out the white spaces between the crossed lines. He gave this up as he developed his much more original method of 'drawing with the graver' instead of cutting round a drawing.

At the time of his death Bewick was working on a print which he intended to produce from three separate blocks. The subject was the old horse 'Waiting for Death' and he had ideas that it would sell as a cheap picture to hang on cottage walls. Its subject and his object are typical of a man who had no pretensions about his work and who managed, in spite of this, to give new life to an industry and to a neglected field of art and craftsmanship.

Tailpiece from British Birds, *by Bewick*

After Bewick

AFTER Bewick's death in 1828 the future of wood engraving must have appeared less bright than his optimistic forecasts had predicted. The potential of the craft had been amply demonstrated but the need had not been fully realised. By far the most important of Bewick's own works had been done for his own purposes and artists had been slow to take any interest in the medium. As it happened, a mistaken attempt to present engraving as an 'artistic' medium for the reproduction of paintings came close to extinguishing the craft. For this purpose it could never rival the intaglio processes of aquatint and mezzotint and any attempt to use it in this way was bound to fail. The greatest achievement in this direction was reckoned to be Harvey's engraving after Haydon's 'Assassination of Dentatus' but this merely served to prove the futility of the attempt.

The lone figure of William Blake stands out from the jobbing engravers as the one artist who used the medium for its own sake at the beginning of the nineteenth century. For Blake engraving was a means to an end and he could not possibly have had the effect upon the subsequent development of engraving, allied to the printing trade, which the work of Bewick had.

Blake was a visionary, the giant among a group who, completely out of tune with their time, saw the implications of the social and moral changes which were taking place and, by crying out in inspired

These engravings, of a printing press and men wrestling, show the use of white-line but in a manner far less sophisticated than that of Bewick

protest, were regarded by the majority of their contemporaries as cranks and eccentrics.

Blake's influence can be traced through the work of the romantic artists, particularly Samuel Palmer, who followed him, and that of the poets, writers and artists who have 're-discovered' him in the present century. The work of Blake, as also of Palmer and his immediate group of followers, lies outside the scope of this present work, although each of them produced engravings of exceptional quality. Blake's only engravings on wood were made when he was sixty-three and they consist of a group of seventeen illustrations to an edition of Virgil, then newly

translated by Dr R. J. Thornton. Sixteen of them measure approximately 3 in x 1¼ in each and they must be, in terms of size, some of the most highly charged areas in the whole history of art. The sheer intensity of such small surfaces is incredible. They were so misunderstood that the publisher handed them over to a craftsman-engraver to re-cut, and they were only saved by the intervention of some of Blake's artist friends. Anything less likely to influence the trade towards the increased use of woodblocks would be difficult to imagine.

So far as the history of wood engraving is concerned Blake's influence was sustained through the work of Samuel Palmer and his immediate followers. Palmer, who lived from 1805 to 1881, was a great admirer of Blake and the two men met towards the end of Blake's life. So far as is known Palmer made only one, small, engraving and even this does not appear to have been proofed until many years later. It is very similar both in size and treatment to Blake's engravings and could easily be mistaken for one of them. Edward Calvert (c 1803-1883), one of the small group who came under Palmer's influence, produced a few remarkable prints which, almost alone, bridge the gap between Blake and the artist-engravers of the present century. The two paths had thus been clearly indicated : the craftsman-engravers serving the printing

Anonymous engravings which show the tendency towards increasing fineness evident throughout the nineteenth century

37

One of a series (much worn by constant use) depicting trades and occupations. Used in Newcastle around the beginning of the last century

trade on the one hand and the 'artists' and original printmakers on the other.

It is, perhaps, ironical that the artists have outlived the craftsmen, particularly as the Art and Crafts Movement of the latter part of the century had a fair amount to do with the revival of wood engraving. An interesting sidelight on the artist-engravers is revealed in the fact

that until very recently the Society of Wood Engravers (founded by Eric Gill to provide a meeting point for artist-engravers) held its annual exhibitions not in an art gallery but at the London Crafts Centre, of which it was a constituent member. In the late nineteenth century the artist had come to regard the engraver with a scorn which was certainly not deserved.

Two prints which stand about halfway between the crude chapbook illustrations and the trade engravers of the late nineteenth century

*An early signed engraving which shows obvious
signs of Bewick's influence*

Bewick's own workshop made little direct contribution to the further
history of engraving after his death. His younger brother John, whom
he had trained as an apprentice and who showed some promise, died
young. Many of the illustrations to Bewick's books had been engraved
by his workmen, but the loss of the master soon became apparent and
standards declined. It was not the quality of the engraving which
suffered but rather the actual designs, for none of Bewick's successors
possessed his powers of observation and draughtsmanship and the time
had not yet arrived when artists of distinction were willing to entrust
their work to the engraver's block.

Several of Bewick's men carried on the tradition of fine craftsman-
ship and thus prepared the ground for the flowering of the era of com-
mercial engraving which was to follow. At least one, William Harvey,

was able to work from his own delicately meticulous but uninspired drawings, but even these were necessarily overshadowed by the too recent memory of their master, and commissions were not easily come by. Harvey, in fact, devoted most of his energies to drawing on the wood for other engravers and dominated the field for more than a decade after Bewick's death. His own apprenticeship no doubt provided him with a fundamental understanding of the qualities and limitations of wood engraving and thus gave him the advantage over other artists, and the time had not yet arrived when engravers would make excellent prints from the most unsuitable of pen and wash, or chalk drawings done on the block by artists with little knowledge of and even less regard for the peculiarities of the medium. Bewick's other most promising trainee, Luke Clennell (who engraved many of Stothard's drawings), had become insane in 1817, and another engraver of great promise, Charlton Nesbit, came into some money and gave up engraving altogether.

A much-worn vignette of a steam locomotive in the
Bewick tradition

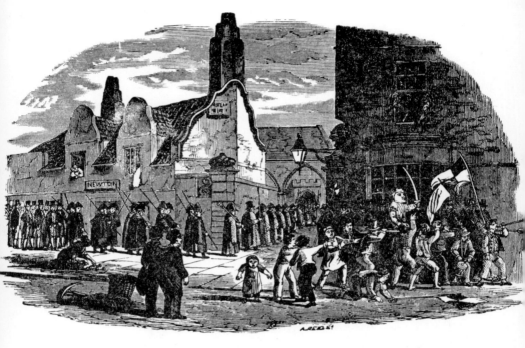

A procession, probably of local significance, engraved by Andrew Reid of Newcastle

With Bewick's men dispersed and the needs of the London market supplied by as few as half a dozen engravers the prospect in the 1830s might have appeared somewhat bleak. But Bewick had not been mistaken. The beginning of a new demand for engravers came with the establishment of two periodicals in 1832. These were the *Penny Magazine* and the *Saturday Magazine,* and they were the forerunners of many, some of which became household names and which brought fame to their artists and fortunes to their proprietors.

'The Call to Vigilance.' Engraved by Luke Clennell for Ackermann's Religious Emblems, *1809*

Title for a cheap book, signed 'Walker'

Aided by such technical advances as the improvement of the method of producing 'stereotypes' in metal from woodblocks, and by such social developments as the rapid increase in the size of the literate public and the spread of railway bookstalls, the demand for engravers grew rapidly and increased continuously until the end of the century. It was met by a number of highly professional and well-organised establishments in which numbers of engravers worked under a master with increasing speed and efficiency. Several of these extended into the printing business and thus made a major contribution to Victorian book production. Their aim in many instances was to rival the lithographic printers, with their highly skilled craftsmen working from stones, and they often did this very successfully.

The number of periodicals grew very rapidly, and with them came the beginning of the boom for wood engravers. The two most famous and influential of the new journals were *Punch* and the *Illustrated London News*. The former was founded in 1841 with a capital of £25. The *Illustrated London News* began publication in the following year and by the end of the century had become a major factor in the

development of the trade of engraving. Both these journals are still in existence, but they were soon accompanied by a mass of others most of which have long been forgotten.

Many came into being as the result of concern shown by religious bodies at the standards of literature available to the working classes in general and children in particular. Such bodies as the Sunday School Union and the SPCK published what must have been extremely attractive printed works of various kinds aimed, it may be assumed, at enticing the young away from a class of periodical later to become known as the 'penny dreadful'. The *Christian Herald* was a prolific user of engraved illustrations, both moral and instructive, and some of the illustrations to this book are from blocks engraved for that periodical towards the end of the last century.

The upsurge of interest in education within the great mass of working people (for this was the period of Morris and Ruskin and the other pioneers of reform) created a market for books and periodicals of all kinds. From the early years of the century the Mechanics Institutes had provided libraries in which men from the 'upper strata' of working

Cheap book or pamphlet title

*Decorative title page. A typical example of engraving
for cheap printed matter*

class occupations could consult authoritative works. In the second half
of the century the various educational movements provided for those
lower down the social scale and sought to arouse an interest in the
arts and sciences, literature and poetry for their own sakes.

The London Working Men's College opened in 1854 and evening
classes soon spread throughout the country. It is not surprising, there-
fore, that from this date an increasing volume of books and magazines
of all kinds flooded the shops and stalls. Before long the insatiable

demands for more and more illustrations were being met not only by an army of anonymous draughtsmen and illustrators but also by a growing number of artists of repute who were employed (not without protest, at times) to provide the engravers with material.

The unknown artists who worked on the great majority of blocks, drawing anything from a storm at sea for a news-sheet to a complicated piece of machinery for an ironfounder's catalogue rank, with the equally anonymous craftsmen-designers of the Middle Ages and the unknown architects who were responsible for so much fine building in England in the eighteenth and nineteenth centuries, among the great artist-craftsmen. It is to their work that we must turn, along with that of rural masons and wagon-builders and others of their kind, for the finest 'popular art' of the nineteenth century.

It was customary though by no means universal practice for the signatures both of artist and engraver to appear on the block, and it is an indication of their relative status in some instances that where the artist was a 'hack' and the engraver a man of repute the latter's signature alone appears, invariably followed by 'sc' or 'sculpt'. Probably the finest and certainly among the most famous and successful engravers were the Dalziel brothers, who founded a business which extended from engraving into printing and publishing.

The Dalziels came, by an interesting coincidence, from Northumberland and were themselves competent painters, illustrators and engravers. In the early days of the business they engraved the illustrations to many now famous works (including Edward Lear's *Nonsense Books*), but as the firm grew and prospered a great amount of general work was also undertaken. Among the most interesting jobs produced by the Dalziel firm were the sumptuous catalogues of the Coalbrookdale Ironfoundry. These superbly produced volumes, illustrated entirely by wood engravings, show the complete range of products turned out by this foundry in its heyday at a time when it could supply anything from a monumental fountain to a cottage grate. The illustrations are of great interest and importance and represent a combination of the two essentially Victorian products—cast iron and wood engraving—from their finest exponents at the height of their powers.

Engraved trade card or advertisement, signed 'E. Spencer. Sc.'

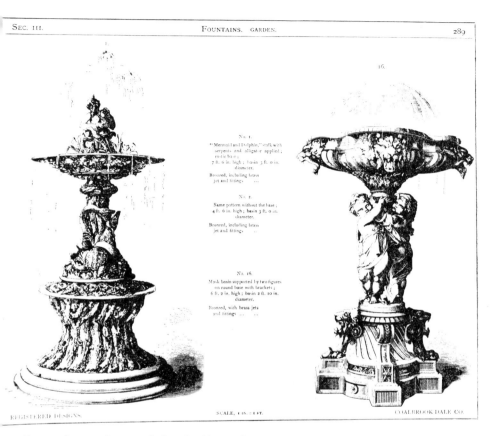

No. 1.
"Mermaid and Dolphin," stalk with
serpents and alligator applied;
rustic base;
7 ft. 6 in. high; basin 3 ft. 0 in.
diameter.
Bronzed, including brass
jet and fittings ...

No. 2.
Same pattern without the base;
4 ft. 6 in. high; basin 3 ft. 0 in.
diameter.
Bronzed, including brass
jet and fittings ...

No. 16.
Mask basin supported by two figures
on round base with brackets;
6 ft. 2 in. high; basin 3 ft. 10 in.
diameter.
Bronzed, with brass jets
and fittings

REGISTERED DESIGNS. SCALE, 1 IN. = 1 FT. COALBROOKDALE CO.

From the catalogue of the Coalbrookdale Company, engraved and printed
by Dalziels. This has been considerably reduced; the original page size was
approximately 11 in x 10 in

D

An engraved label (?) and trade-mark

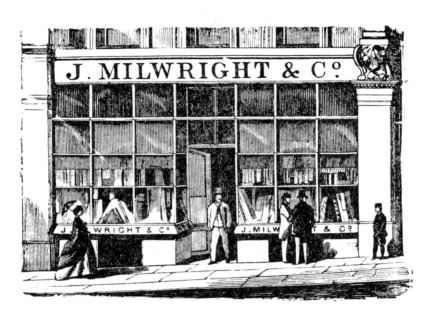

top: *Engraving of a shopfront, probably for use in
advertisements;* bottom: *an excellent example of
highly-skilled black-line engraving*

An engraving by Edmund Evans illustrating The Poetical Works of Oliver Goldsmith *published by J. & C. Brown and Company, London. Signed at the bottom right-hand*

Another master-engraver of the period whose business included fine printing was Edmund Evans. Evans was apprenticed in 1840 to Ebenezer Landells, an engraver who worked in association with a printing house and who was one of the founders of both *Punch* and the *Illustrated London News*. Evans set up in business on his own account soon after completing his apprenticeship and eventually achieved a considerable reputation as a colour printer. Using a separate block for each colour, the best of the work done by Evans rivalled that of the lithographic printers and, because of the comparative cheapness of letterpress

52

printing, his work was in great demand. He produced and printed books for many leading publishers, some of them still flourishing.

Occasionally as many as twelve blocks were used for one coloured picture, but for the bulk of the cheaper productions three or sometimes four sufficed. These, often gaudy, prints have a unique quality which, whilst it may not appeal to contemporary tastes, has a very strong period flavour which no other process produced. For decades the books and magazines in which they appear have been regarded as 'junk' and treated accordingly, but I suspect that they may soon be restored to popularity and become 'collectors' items'.

A fellow-apprentice with Edmund Evans was Birket Foster, whose watercolours are as typically Victorian as it is possible to be. As an apprentice his capacity for drawing was recognised and it is hardly

An illustration to The Poetical Works of Oliver Goldsmith, *drawn by Birket Foster and engraved by Dalziel. Both signatures can be seen on the print*

surprising that, with his gifts as a draughtsman and painter and his training as an engraver, Birket Foster became one of the most prolific, and best, illustrators of his time. His work must have become known to millions and for its freshness, lively draughtsmanship and exquisite engraving merits the comparison with Bewick. Some of his finest work, engraved by Evans, is to be seen in the frequently reprinted set of illustrations to the works of Oliver Goldsmith, first published in 1851. Birket Foster's watercolour drawings, exquisite as they are, are too sentimental for modern tastes.

Along with his contemporaries, A. Boyd Houghton, Fred Walker and G. J. Pinwell, who were also popular watercolourists, Foster's most acceptable work to present-day eyes is his pen-drawing for engravings. As was common practice, the Goldsmith book was illustrated by a number of different artists and thus affords an opportunity for comparing Foster's work with that of his lesser contemporaries. In the same book a variety of engravers was also employed and this, too, was not unusual. All of these blocks must have been used many times over for different editions.

In the latter part of the century, when wood engraving had reached its climax of perfection as well as popularity, most of the leading artists worked directly on to the block for the engraver to cut. Some, like Rossetti, conceded nothing to the medium, leaving the craftsman to interpret not only complex cross-hatching but even washes. The skill with which results were achieved from such originals is incredible but they did not always meet with the approval of the artists, who sometimes complained unjustly at the 'mutilation' of their original drawings.

Millais, and most of the other Pre-Raphaelites, produced numerous drawings for the medium and the books which contain them are well worth hunting out from the dusty piles in second-hand bookshops. Following these came a whole generation of artists for whom the pen-drawing on wood was the prime medium. The greatest among these was undoubtedly Charles Keene, one of the most under-rated artists of the century. Degas, Monet, Sisley and Sickert were all great admirers of Keene's work, nearly all of which was produced for use in *Punch*.

Catalogue illustration for Ransomes Sims & Jefferies Ltd. The background would not need to be cut away as an electrotype would be made of the engraved portion of the block

Catalogue illustration

Many other artists of considerable talents worked for the publishers and engravers and they are adequately listed elsewhere, but it would be improper to leave out from any review of such artists a mention of the Frenchman Gustave Doré. With an enthusiasm matched by his energy and invention, if not by his capacity to avoid banality on occasion, Doré produced illustration after illustration for some of the greatest works of literature. They included *Don Quixote, Paradise Lost,* the *Divine Comedy* and, of course, the Bible, and they presented the engraver with some of the most formidable tasks in the history of the craft. Doré's finest work was undoubtedly his volume on London in which his superbly observed drawings are matched by the quality of engraving and printing. These illustrations are one of the best sources of information on London life and show how much better Doré was at objective recording than 'imaginative' composition.

The works of Doré, the *Punch* artists, the Pre-Raphaelites, and the other 'fine artists' are now justifiably acknowledged, but they represent only a fraction of the work undertaken by the commercial engravers.

In catalogues, broadsheets, leaflets, magazines, labels, packages, advertisements and all the 'throw-away' ephemera turned out by the presses, an apparently limitless number of engravings appear. Many of them now have a quaint charm (particularly, for example, those which appear as illustrations to advertisements in guidebooks and which show the latest fashions in costumes, transport, hotels, luggage, etc). Others are a useful source for the social historian or industrial archaeologist on apparently forgotten aspects of nineteenth-century life.

The skills of the nineteenth-century engravers have never been equalled, and the capacity of the engraved line for rendering the

A late-Victorian illustration showing the skill with which a good engraver could interpret a drawing

minutest detail with the utmost precision is unique. Some engravings are still to be seen in use in catalogues of old-established firms and where they appear beside photographs, or photographic reproductions of line drawings, their superiority is undeniable.

The commercial engravers were doomed to extinction not because the quality of their work was inferior but because time, and therefore also money, was against them. A few, in Britain and America, have survived on specialist work until the present time but it is unlikely that they will continue for much longer. The future must lie with those artists who respond to the feel of the graver in the wood, and who recognise the peculiar quality of the engraved line and the image produced by ink transferred from wood to paper.

Illustration to a mathematical textbook, backgrounds not cut away. Date uncertain

Technique 1: Materials and tools

OF all the methods employed for obtaining a printed image, that of wood engraving must be, basically, the simplest. It is a humble craft, sharing its fundamental principles with the potato-cut and the lino-cut, which are now commonplace even in primary schools. Its material —boxwood—can hardly be called sophisticated, and the tools which the engraver uses are extremely simple. Even the knife used by the wood-cutters is a more difficult implement to handle than the engraver's tools and neither approaches the complexity of implements and acid baths used by the intaglio platemakers.

From a simple block of wood and a sharpened metal bar the wood engraver produces the printing surface which has yet to be rivalled for its delicacy, its accuracy or (in the hands of a master) its potency. Although the engravers of the last century were able to devise methods for speeding the process of engraving, and used ways of extending the capabilities of both material and method to their limits, the fundamentals remained simple and unchanged. Nothing can be more direct or straightforward as a printing process than rolling ink over the surface of a block and transferring it to paper by pressures exerted on the back. Nothing could be more straightforward than the method of removing parts of the surface in order to achieve white interruptions to the

black surface when printed.

The most comprehensive work on the technique of wood engraving was produced by John Jackson, a pupil of Bewick born at Ovingham, twelve miles from Newcastle, in 1801. His monumental *Treatise on Wood Engraving*, although written by a Mr Chatto, was illustrated largely by Jackson himself and published at his own risk and expense. A more thorough work would be difficult to imagine and it has remained unchallenged since its first publication in 1839, nine years before Jackson's death. It contains some of the most technically advanced engravings ever produced and illustrates the ingenuity with which a simple process can be extended to produce extreme subtlety.

It is doubtful whether some of the methods described and illustrated by Jackson could ever have been widely adopted, but as examples of the possibilities of the craft they are of great interest. Jackson can be forgiven for failing to foresee that time, not complex refinement, was to be the dominating factor in the history of engraving for the rest of the century. This is, perhaps, fortunate, for he has left us one of the most fascinating and detailed books in the history of any craft.

Most of Jackson's technical information applies equally to wood engraving today, although modern artist-engravers tend to avoid most of the complexities and it is unlikely that any have ever even experimented with such difficult techniques as the fractional lowering of parts of the surface to obtain slightly thinner films of ink. Such niceties demand time and skill both in preparation and printing which it would be difficult to find today. In order to understand such refinements it is necessary to explain the more fundamental aspects of the craft.

The wood used is box. It is possible to engrave on other woods, or even plastics, but nothing else has the crispness of the boxwood, or its regular close grain, free from any tendency to distort or to crumble. No engraver who is accustomed to box can ever take kindly to any other material. In Jackson's opinion English box was superior to all others, but most contemporary blocks are made from wood from Venezuela, South Africa, or Persia, partly because English wood is very slow-growing and difficult to come by, being in demand for a variety of purposes.

Engraved illustration. White lines show where the individual pieces of wood in the block have split apart

The disadvantage of the box tree is its small size. When cut horizontally the diameter is seldom more than a foot at the most, and the need to 'square up' reduces this considerably. The quality of wood varies from tree to tree, even different parts of the same section often varying in hardness, so that in order to obtain a large block of the first quality the blockmaker must join a large number of small pieces together in such a way that the joins will have no effect either on the engraver or the print. When blocks are kept in poor conditions there is a tendency for these joins to split apart, as can be seen in some of the illustrations to this book. Although suffering from this disadvantage the boxwood block has one advantage over those used in woodcutting : it is not subject to the ravages of the woodworm. The worm-holes which mar the original woodblocks of Dürer will never disfigure the engravings of Bewick, although splits and cracks unfortunately do.

The greatest hazard to a boxwood block is excessive dryness, such as is caused by central heating. Although unknown to Bewick this form of heating is not unknown in some of the places in which his blocks have subsequently been kept, and the inevitable result has been the splitting of the wood. Even Bewick was unfortunate enough to expose the block of what he regarded as his major work—the Chillingham Wild Bull—to sunlight, with the inevitable result. Proofs of this in its perfect state are therefore very rare. A block left exposed even to mild sunlight can explode with a crack like a pistol shot and it is a sound calculated to cause consternation in an engraver's workshop.

Small cracks and surface dents can be restored by placing the block face-down on blotting paper for a short time, and constant use or even occasional proofing help to keep a block in good condition. The atmospheric conditions are so important that Jackson went so far as to suggest that a good engraver's hands should be warm and moist. Large blocks (ie any more than a couple of inches in any dimension) have to be made by joining small pieces together. This is usually done by tongueing and glueing, but in order to meet the needs of the commercial engravers towards the end of the century a method of bolting was devised.

Even before the middle of the century a form of division of labour

Illustration, engraved in facsimile, of a pen drawing.
Note the intricate engraving of the cross-hatching in
the boy's jacket

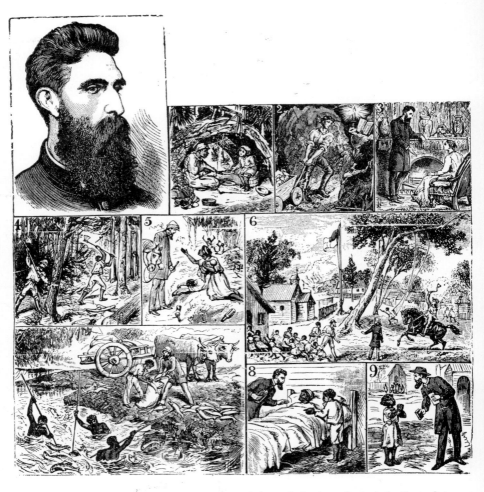

A typical story sequence (the origins of the 'comic strip'). Complete
block (reduced) and detail opposite (actual size)

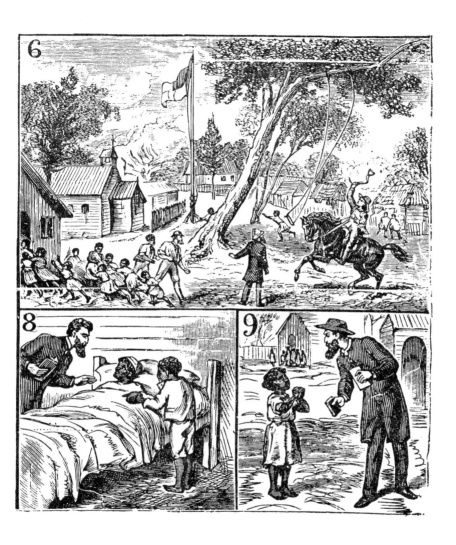

E

was being employed whereby each engraver in an establishment might specialise in certain aspects of the work—skies, figures and so on. This was nothing new in the history of art. Most of the great Renaissance artists worked in this way, leaving their pupils and apprentices to do the routine work and themselves giving the 'final touches' to what must have been virtually completed works, and Rubens ran what amounted to a paintings factory. In the Victorian trade engraving houses the practice, which began in order to make the best use of available talent (in a way very similar to that in which some modern advertising agencies work), developed into a method for speeding up production. Instead of handing a block round from engraver to engraver, a large block would be made from many small pieces bolted together. Once the original drawing had been made the block could be unbolted and each piece dealt with by a different workman. The edges of the pieces would be left uncut until the block was re-assembled and finished by the master engraver. Alternatively, the master engraved across the join first. In this way news pictures could be speeded on to the presses and appear with surprising punctuality in the pages of such journals as the *Illustrated London News*.

Before engraving, the surface of the wood has to be prepared in such a way that it can receive the drawing which is to be reproduced and at the same time remain perfectly smooth and level. Jackson, incidentally, distinguished between 'interpretive' and 'facsimile' engraving and rightly stresses the importance of 'spirited execution'. Commenting on the merely reproductive engravings, he says that 'mere delicacy of line will not, however, compensate for want of natural expression, nor laborious trifling for that vigorous execution which is the result of feeling'. One cannot help supposing, however, that spiritless facsimiles were what most publishers and printers were after, and the preparation of the block to receive the artist's drawing was therefore of vital importance, since every line would be expected to appear with unfailing accuracy in the print, however unreasonable it might be in terms of engraving.

Jackson, who had learnt under an enlightened master how to interpret rather than copy, and thus to enjoy an equal status with the artist,

Lettering and black-line on a minute scale

must have been sorry indeed to see the way in which the trade was moving towards slavish imitation.

The recipe which he gives for smoothing the surface is a mixture of powdered Bath brick with a little water, rubbed off when dry with the palm of the hand. The surface should then be drawn on with pencil, after washing in with indian ink. 'By this means the hard edges of the Indian-ink wash will be softened, the different tints delicately blended, and the subsequent touches of the pencil be more distinctly seen.'

An alternative method was to whiten the surface with a mixture of flake white and gum, but this had the disadvantage that it was liable to flake off. It also tended to mix with proofing ink and thus to block some of the finer lines in printing. Present-day engravers use a variety of methods, the most practical being to stain the surface lightly with thin ink and to make the drawing with a darker ink. The stain makes it possible to see quite clearly the effects of the tools as the engraving is made, as well as making a good base on which to draw the design. French nineteenth-century engravers were reputed to have treated the surface of their blocks with a solution obtained by boiling shavings of parchment.

Illustration for a magazine. On the background are marks made by testing tools for sharpness

The tools used for engraving are made from solid bars of metal of varying sections, not gouges as are used for present-day lino-cuts. Although it is possible to obtain a very considerable range of tools, each one making its own characteristic marks on the block, they fall into four main categories. These categories are variously named gravers (or, alternatively, burins), tint tools, scorpers (or scaupers called, more descriptively, by Jackson 'scoopers'), and spitstickers. In addition to these are tools known as bullstickers (now more or less defunct) and multiple gravers. Small chisels mounted in graver handles are also used.

Each of these tools consists of two parts, the metal shank of the cutting tool proper and a small wooden handle into which it is set. The handle is shaped like a half mushroom so as to fit into the palm of the hand without touching the surface of the block. The shank is some-

times slightly curved to lift it away from the surface of the block when in use, with the cutting end ground back at an angle of approximately forty-five degrees to the axis of the shaft. Tools for metal engraving are very similar except for the angle at which they are ground, which is steeper for greater strength, and the shape of the handle which is usually more like a knob to allow greater pressure to be exerted.

The basic tools, although not necessarily those most used, are the gravers, and these are diamond in section. The cutting point makes a clean, precise incision which can be varied in thickness by slight changes in the angle at which it is held. When used for small marks, or stipple, rather than line, the graver produces small triangular incisions. The particular attraction of the graver is its flexibility and for even lines of constant thickness a different tool is used.

Catalogue illustration. Multiple gravers have been tested on the background and used in the shadowed areas

Since it was the practice of the reproductive engravers to imitate washes or tints by fine parallel lines the tool used for the purpose was referred to as a tint tool. The actual cutting edge of the tint tool can be either a point or slightly flattened, according to the width of the lines which it is required to engrave. The sides of the tool are straight, in order to minimise the effect which any slight variation in the angle at which it is held might have.

Spitstickers are all-purpose tools equally useful for stipple or line.

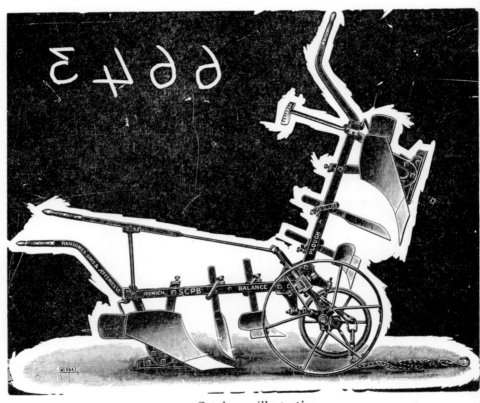

Catalogue illustration

They are similar to pointed tint tools, but the sides of the shank are curved and this allows a degree of variation in use. As with all the other tools, spitstickers are obtainable in a wide variety of sections to meet all needs. The last category of tools, the scorpers, are used mainly for cutting away large unwanted areas, such as white backgrounds or the corners of vignettes. The sides of the shank of a scorper are parallel, giving a cutting edge similar to a very small chisel. The actual cutting edge can be either straight or curved, each shape serving a particular purpose. The round scorper offers less resistance to the wood, and is thus useful for cutting away large areas. It can also be used for producing half-moon stipple or, if the block is rotated beneath it, round dots. The square scorper is useful for cutting up to engraved lines (Jackson advised the cutting of the whole design in outline as a first step) and also for characteristic rectangular or triangular stipple. The bullsticker was a variant of the spitsticker which had convex sides.

The multiple graver was devised towards the end of the last century to facilitate the more rapid cutting of parallel lines but it is doubtful if it was as widely used as has sometimes been suggested. It is rather like a square scorper, the cutting edge of which is zig-zagged, producing the effect of a series of graver points, equally spaced. It is an unwieldy tool which, for some artist-engravers, has had a novelty appeal, and its weakness is in its rigidity. For rapid tinting the lines would have to be finished off individually with a graver or tint tool, thus reducing its apparent advantage, and if carelessly used it easily has the effect of a scorper, cutting too deeply and leaving a white area instead of lines.

Also towards the end of the last century a ruling machine was produced but its limitations were even more apparent than those of the multiple graver and it must often have been more trouble than it was worth in a busy workshop, always short of time. Small chisels, up to $\frac{1}{2}$ in wide, mounted in graver handles, are used for lowering the edges of the block to avoid the danger of their picking up ink during printing.

These are the only tools used by the wood engraver and although the professional craftsman would have had his own set of upwards of a dozen it is quite possible to engrave very varied designs with as few as three.

A proof from an engraving done entirely by ruling machine as a demonstration of the qualities of East London boxwood

Technique 2: Engraving and printing

AS with any form of engraving, the design on the block is reversed in printing. When lettering, or recognisable buildings or similar subjects were to be engraved the artist needed to reverse the design on to the block by means of a tracing. When the artist drew directly on to the woodblock without an original on paper, then the design which finally appeared would be the reverse of that which he had engraved. The reversal of designs poses, in fact, few problems, and it makes no difference at all to the actual process of engraving. Many of the commercial engravers must have worked almost by habit, taking as little notice of the actual subject as a contemporary Monotype keyboard operator does of the text which he is setting. Shapes are shapes, whichever way you may choose to look at them.

Having transferred the design to the block, or drawn it himself (for many of the best engravers did this when possible), the engraver was ready to start. In order to raise the block to a suitable height, with the hand resting on the workbench level with the printing surface, the block was placed on a hard leather sandbag. These vary in size according to the size of the block to be worked but an average is about six inches in diameter. The thickness of the block itself was always 'type high', that is, equal to the diameter of a shilling. Like the standard

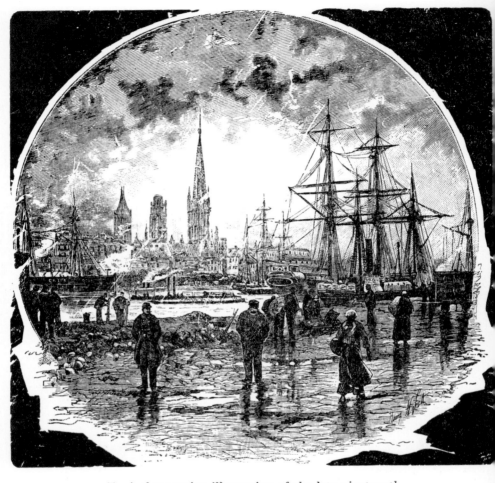

Typical magazine illustration of the late nineteenth century. Note the cutting of the artist's signature

railway gauge and a number of other now universally adopted measurements, the height of printing types from foot to face depended upon an accident of fortune, occurring centuries ago.

The thickness of the block and sandbag together are sufficient to keep the left hand just below the surface of the block. The tool is held in the right hand, the left being used to control the movement of the block. In engraving curved lines it is better to turn the block rather than the tool, the movement of the tool being somewhat restricted. With the handle pressed into the palm of the hand and the cutting tip just forward of the thumb and forefinger, the tool is moved by arching the hand slightly and moving the tool across the surface of the block. The wood holds the tip of the tool making it easy to control, and the forefinger guides it. One of the most pleasant sensations for an engraver is that of a well sharpened tool cutting crisply across a good block, pushing a tiny curl of wood before it. A slip will only occur if the tool is blunt or wrongly held. Mistakes can be remedied, but the process is a difficult one, most contemporary engravers preferring to let the blockmaker deal with it if it becomes necessary.

If errors, such as a slip of the graver, have to be corrected, then the only way to do so is to cut out the area involved and insert a plug. This has to fit so exactly that the joins between the plug and the original surface are perfect and completely indiscernible. The two surfaces have also to be levelled exactly without the slightest damage to that part of the block surrounding the plug. One imagines that the craftsmen engravers, although capable of undertaking such an operation, would take every care to avoid the necessity. For small errors such as slight dents they would keep a few nails handy, sharpened to different sections. These could be driven carefully into the block at the point of damage, and a slip of boxwood inserted. Protecting the surrounding surface with a sheet of paper, the boxwood could then be levelled by careful use of a chisel or a tint tool used on its flat side.

Sheets of thin, glazed paper with a hole cut through them were used to cover the block whilst engraving, when the original drawing was in pencil and thus liable to smudge. It was even necessary at times to wear a face mask in order to prevent the moisture in the breath from

Illustration, probably an interpretation of a pen and wash drawing

softening a drawing in wash or on a flake white ground. Smudging was not the only problem : in the days before electricity or even gas lighting was readily available engravers had to work by the light of candles or oil lamps. This inadequate illumination could be improved by focussing through a glass globe filled with water.

These globes were still being made to order until very recently by the Whitefriars Glassworks, but they are now museum pieces. At least the modern engraver has easier means of lighting his block, although the old globes were surprisingly efficient and they enabled the nineteenth-century engravers to work through the night in order to meet a press deadline in the morning. There is something Dickensian about the picture of the engraver with his eye-shield and mouth mask working in the tiny pool of light cast by a candle through a water globe. It is a subject which Joseph Wright would have relished.

Edmund Evans wrote in his memoir of the effect of working overnight on urgent blocks and it must have been a very tiring experience. The engraver sometimes used a magnifying glass on a swivel stand and with its aid was able to engrave so finely that a magnifying glass is also needed to examine the detail in the print. Examples of such incredibly fine engraving can be seen in several of the illustrations in this book, and even now the photographically produced line-block cannot rival

the quality of some of these commercial engravings. Evans engraved most of the illustrations by Randolph Caldecott and Kate Greenaway, which seem to characterise so well the latter part of the last century, and on one occasion he made comparative blocks of a drawing by photographic line-block and by engraving.

The experiment proved the superiority of the hand methods, which were therefore used, although the drawings were in fact photographed on to the surface of the wood. This was a common practice from at least as early as the 1870s and it had the advantage of absolute accuracy as well as leaving the engraver completely free to develop an interpretative style, unhindered by the need to copy artists' whims when the subject itself was photographic. Many of the later catalogue illustrations were done in this way, the carefully graduated line shading over a photographic base being much more direct than carefully copied cross-hatching.

A delightfully sensitive interpretative engraving (compare the engraving of the curtains with parts of the contemporary print by George Tute on page 119)

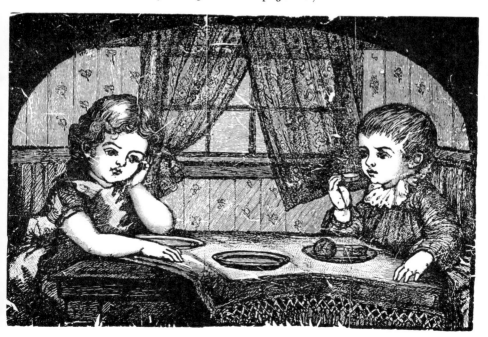

left : *An example of the incredible fineness of some commercial engraving;* bottom : *catalogue illustrations, engraved over a photograph transferred to the block*

The actual procedure followed in engraving any block will depend upon the habits of the engraver or, in commercial establishments, the 'rules of the house'. It was standard practice to leave any large white areas until last, when they would be dealt with separately, possibly by an apprentice using a routing machine.

Many of the illustrations show the actual engraving completed but the large white areas untouched, and thus still printing as black. The lowering of backgrounds was, of course, less skilled than the actual engraving but it was nevertheless important to cut the block to the required depth without damaging the fine work. Insufficiently lowered backgrounds easily pick up ink, and it was important to avoid such difficulties when printing. Many of the popular, cheap books of the last century which had engraved covers and illustrations had first printings of as many as a hundred thousand copies and it was obviously impossible to stop the presses to deal with badly lowered areas which might pick up ink.

Nowadays wood engraving is regarded almost exclusively as a black and white medium (although the writer has produced engraved paperback covers in two or three colours), and it is often forgotten that it was once used for a great deal of colour printing. If an engraving was to be in colour then a separate block would be required for each colour printing and the design, in the form of a 'key', would need to be accurately transferred to the surface of each block to allow for accurate registration (ie correct superimposition in printing).

Evans describes how he engraved key blocks from Kate Greenaway's drawings and then gave her proofs to colour. From these tinted proofs he produced the various colour blocks, using the original block as the key. The design on the key block can be transferred by taking a wet proof and then placing the second block on to the proof and either burnishing or running it through the press so that the sticky ink transfers to the surface of the block. This can be done as frequently as is necessary to obtain sufficient blocks for a colour design.

Hand proofs can be taken, as already described, by placing paper over the inked block and burnishing the back of the paper with a suitable implement (the flat end of a spoon serves as well as anything).

79

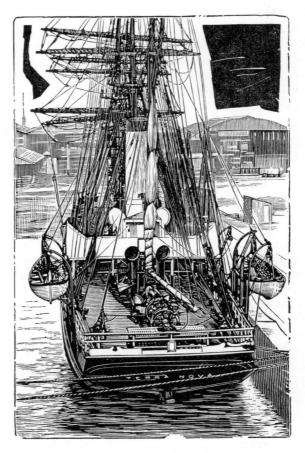

An engraving, probably made from a photo-
graphic original, showing effective and skilled
use of light background, 1905

80

A charming example of fresh, if slightly crude, drawing nicely interpreted

To obtain really good results the quality of the paper is of great importance. It has to be either soft enough to mould itself to the surface of the block, or smooth enough to meet the surface perfectly. Hard, rough paper can only be used if it is first damped in order to soften it, and for this reason most hand-made papers, which are usually heavily sized, are unsuitable. The results of using an unyielding hand-made paper for wood engravings can, unfortunately, be seen in some of the publications of the Golden Cockerel Press, which did so much to encourage the revival of wood engraving between the two world wars. They sometimes allowed a preference for expensive hand-made papers to outweigh considerations of suitability as, for example, in the *Chester Play of the Deluge* in which David Jones's superb engravings are spoilt by totally unsuitable paper. They would have looked better printed on newsprint!

For individual hand-proofs for exhibition purposes one of the most favoured papers is Japanese mulberry paper. This is very soft and is made in a variety of weights, colours and textures. It is also rather fragile and comparatively expensive. There are now a number of good machine-made papers available which are ideal for printing from

F

Facsimile engraving (including the lettering) for a label

woodblocks, and these range from soft printing cartridge to some beautiful smooth (but not surfaced) papers from British mills.

The paper to avoid is art or imitation art whose highly polished coated surface destroys most of the more attractive qualities of the engraved block as well as being unpleasant to the touch. Any examination of illustrated papers and books from the last century will show that a range of suitable papers was available even then, although it was also usual for printing machines to put more weight behind the 'impression' than should happen with modern machines.

Most proofing, certainly that in a commercial engraver's workshop or printing house, would be done on a machine, and for more than half a century the Albion reigned supreme. This, and its rivals such as the Columbian, was the standard press for proofing and for the production of small-run jobs such as posters and handbills in practically every printing establishment in the country.

They were beautifully designed and made and are also lovely things to look at; their quality is indicated by the fact that second-hand ones are much sought after today. The Columbian has a cast-iron eagle perched (as a balance weight) at the top of the machine and is familiar to thousands who have never set foot inside a printing office because of its popularity with the makers of 'wild west' films. Many of the original bills and posters displayed in the American Museum at

*Portrait, boldly engraved for a magazine, with much
greater impact than a half-tone block*

Claverton (Bath, Somerset) must have been pulled on Columbians and Albions, but they were not confined to the cowboy-and-Indian territories. By the middle of the last century the 'inventors and manufacturers of the Albion Press' were able to advertise 'upwards of 5,000 of these Presses have been made, and are at work in every part of the known world'. The same advertisements contain references to the 'New Patent Wharfedale Machine' on which the production runs of many of the books and magazines would have been made.

The Albion and Columbian presses have a sliding bed on which the block and/or type could be placed and inked. The bed rolls, at the turn of a handle, under a heavy metal block which is then pressed on to the paper covering the matter to be printed by the action of a lever. The principle is simple enough but these were complex and exquisitely balanced machines capable of minute adjustments of pressure.

Most modern proofing presses exert pressure on the paper by passing a roller over it. The Wharfedale (a machine still very much in use) passes the type and blocks beneath a roller with paper fed between, and ink applied on another roller. This type of machine was used for nearly all letterpress work of any quantity, until the invention of machines using type in the form of stereo plates wrapped around a roller avoided the 'return journey' of the bed, which virtually wastes half the time when a Wharfedale is running. Victorian jobbing printers concerned mainly with small jobs would use a platen machine with a foot treadle. These also had names such as Arab, Victoria and Cropper which were household words in the printing trade. They were ideally suited to the printing of wood engravings.

The development of photographic methods for producing printing blocks was certain, in the end, to cause the downfall of commercial engraving, but not before the engravers had exploited every possible aspect of their craft, and even then the quality of the engraving was never equalled. Jackson had illustrated reproductions from Rembrandt paintings as examples of the versatility of the craft. These masterly prints were built up from a number of blocks, one cut in low relief to give the impression of the varied surface of the painting. But such feats of virtuosity were doomed to failure with the development of the more

*The wood engraving meeting the half-tone on its own
ground and still retaining its particular character*

accurate, if in some ways less attractive, photographic processes.

Even earlier there had been various developments, some producing charming results, of wood engraving in combination with intaglio. These included the now forgotten 'Knights Patent Illuminated Prints and Maps' which involved a complicated process in which the bed of the printing press revolved under each of a series of plates in turn, the woodblock being last. More successful, and now much sought after by collectors, were George Baxter's prints in which a development from 'chiaroscuro' engraving was employed. Baxter used an aquatint plate

The end of an era. An illustration engraved when the wood
engravers were losing the battle against the half-tone block, 1912

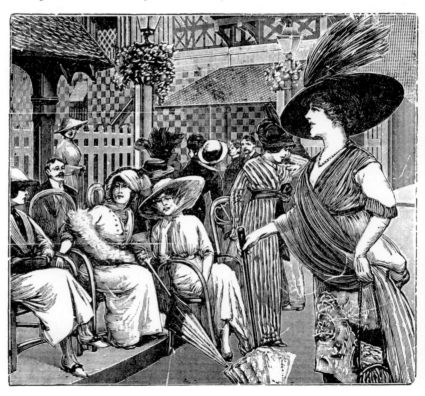

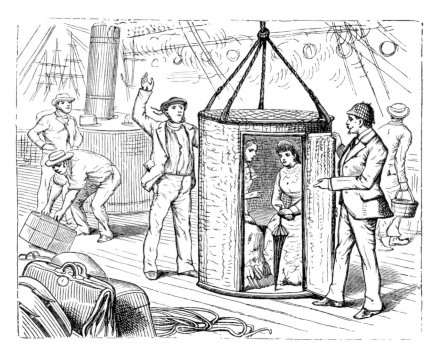

A late example of facsimile engraving, cutting round a line drawing with no attempt at interpretation. One of a story sequence

for most of the detail and tonal variation in his prints, adding the colours by a succession of up to twenty woodblocks, the whole printed in oil colours. Baxter prints were deservedly popular, some of his best work appearing in a *Pictorial Album* published by Chapman & Hall in 1837, but the process was not taken up to any extent later.

The final blow to the professional engravers was the photo-process half-tone, which reduces tonal variation to a series of dots and which is still the basis of a vast amount of colour and black and white printing. For a time the engravers were able to beat the half-tone at its own game. Early half-tone prints are poor in quality with an unattractive overall greyness, and the engravers learnt from the half-tone the lesson

87

An illustration engraved in 1913

of continuous tonal gradation by line and dot. Woodblocks which attempted to beat the photo-process at its own game are undoubtedly attractive and vigorous (as, for example, some of the portraits illustrated) but they could not win against the growing flood of illustrative material pouring into newspaper and periodical offices.

Although one or two of the blocks illustrated were produced as late as the outbreak of the Great War, and a few commercial engravers have survived on specialist work in Europe and America into the present decade, there can be no doubt that, however we may regret its loss, the wood engraving as a commercial process is as dead as the mezzotint.

*A late example of engraving in which the
background has been lowered so as to
print lighter than parts which require
emphasis*

CHAPTER SIX

Stock-blocks

THE idea of the stock-block is as old as printing. The stock-block is merely an all-purpose illustration stocked, in block form, by the jobbing printer for use as the occasion demands. A large proportion of the blocks used by the earliest printers could be classified under this heading as they were used over and over again in differing contexts and differing degrees of relevance to the text which they were supposed to be illustrating. The modern stock-block, however, is a largely nineteenth-century product which, like the woodblock, had its origins in earlier forms and which has now practically outlived its usefulness.

Many small jobbing printers still have trays of old stock-blocks, which they may occasionally use for such jobs as bill-heads or tickets, but changes in public taste are making even these less commonly in demand, and most of the block trays are gathering dust or, along with the older woodblocks, thrown out when the space which they occupy is required. Most customers who now require illustrations to their printed matter are able and willing to have the blocks made specially for the purpose, and the stock-block, if it is used at all, is likely to be regarded as a pleasant old-fashioned oddity. Its contemporary equivalents are the sheets of transfer illustrations produced by the firms who make transfer lettering, suitable for the more sophisticated printing processes which are taking over from the jobbing printer in so many aspects of work.

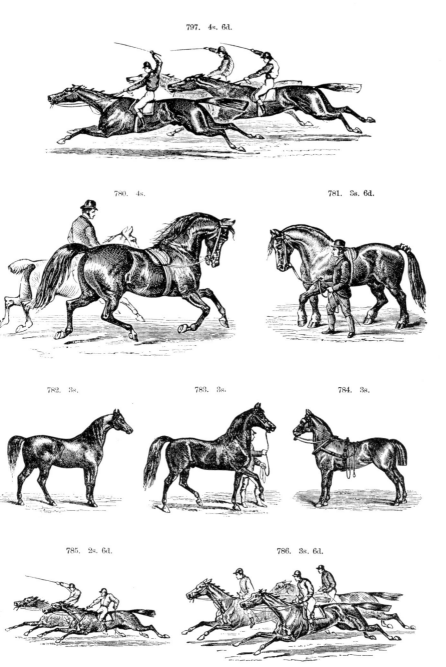

797. 4s. 6d.

780. 4s.

781. 3s. 6d.

782. 3s.

783. 3s.

784. 3s.

785. 2s. 6d.

786. 3s. 6d.

STEPHENSON, BLAKE & Co.

A page from the stock-block section of a Stephenson Blake catalogue

THE
SAILOR'S FAREWELL.

THE
ROVER
OF THE SEAS

Farewell ! Mary, I must leave thee,
 The anchor's weighed— I must aboard,
Do not let my absence grieve thee,
 Of sorrow do not breathe a word :
What though the foaming ocean sever
 Me from thee, yet still my heart
Loves you, Mary, and will ever,
 Though stern duty bids us part.

Farewell ! Mary, dearest Mary,
 Do not grieve, I shall return
Crown'd with laurels, pray do smother,
 That sad sigh, oh ! do not mourn,
You unman me with your kindness,
 Oh ! chase these tears off my brow,
Now round thy lips sweet smiles are creeping,
 Bless thee, Mary, farewell now.

Farewell ! Mary, do not weep so,
 Though I leave thee for awhile,
I'll love thee still when on the deep now,
 Cheer my heart with thy sweet smile,
Soothe my parents with thy kindness,
 And I'll bless thee when far away,
Oh ! forgive my youthful blindness
 For I can no longer stay.

Dearest parents, farewell kindly,
 Rest content whilst I'm away,
Mark that gun, 'tis to remind me,
 On shore I can no longer stay ;
The anchor's weigh'd, the sails are spreading,
 The boat is waiting in the bay,
Farewell now all kind relations,
 Pray for me when far away.

I'm rover of the seas,
 And chief of a daring band,
Who obey all my decrees,
 And laugh at the laws of the land.
Wherever my swift bark steers,
 Desolation and rapine are spread,
And the names of the famed buccaneers
 Fill the bosoms of all with dread.
 For I'm Rover of the Seas—
 Ha ! ha !
 For I'm Rover of the Seas.

King of the waves am I,
 And rule with despotic sway,
As over the waves I fly,
 In search of my lawless prey.
No mercy I ever show
 To any I chance to meet—
But 'neath the billows they go,
 For dead men no tales repeat.

I'm the terror of the main,
 For none yet has conquered me,
And every victory I gain
 Makes me firmer the lord of the sea;
In storm, or in calm or in fight,
 I ever am the same,
And dearly have earn'd the right
 To claim my blood-stain'd name.

I envy no king on shore,
 For there's none has power like me,
They're bound by the oath they swore
 While I am reckless and free ;
And tho' danger I meet each day,
 Yet merry my life is pass'd
For let there come what may
 I can but die at last.

[14]

WALKER, PRINTER, DURHAM.

Pages from a book of ballads (reduced) printed in Durham. The illustrations obviously come from the printer's stock, that of the ship being possibly by Bewick and the others much cruder

THE BOATMAN

Of de Ohio.

De boatman dance, de boatman sing,
De boatman's up to ebery ting,
And when de boatman comed on shore,
Him spend him money, and him work for more.
 Dance de boatman dance, &c.

We'll dance all night till de broad day light,
And go home with de gals in de morning,
Heigho de boatman row,
Floating down de riber Ohio.
 Dance de boatman dance, &c.

I went on board de oder day,
To hear what de boatman had to say,
And dere I let my passion lose,
And they popt me in de cabiboose.
 Dance de boatman dance, &c.

If eber you go to de boatman's ball,
Dance wid dat nigger not at all,
Sky blue jacket, tarpauling hat
Look out, my gals, for de nine-tail-cat.
 Dance de boatman dance, &c.

Ober de mountain slick as a eel,
Dats were de boatman bends his heel,
De winds may blow, de waves may toss,
By golly, I tink de boatman's lost.
 Dance de boatman dance, &c.

DE COLOR'D FANCY BALL.

Oh! when soft music's sounding, de yaller gals to
 enthral,
What light joys then are found in de coloured fancy
 ball ;
Now den ebery fiddler is ready, de tune am gwarn
 to give out ;
Any gentleman making a riot will be sent to de right
 about.
Now de banjo sweetly sound, yaller gals are glancing,
Whirling, twirling quickly round, oh, de joys ob
 dancing.—Oh! when soft music's sounding, &c.

Hark to those strains so winning, here a waltz we
 now begin,—
There polkas are beginning, come, yaller gals, fall in :
Strike on ebery banjo loudly, to make de fat gals
 step out,
Color'd genblemen den will feel proudly, and skip
 high if eber so stout.
Now den to de fiddle's sound, waltzers are advancing,
Whirling, twirling quickly round, oh! de joys ob
 dancing.—Oh! when soft music's sounding, &c.

WALKER, PRINTER, DURHAM.

PRIME THE CUP, FILL IT HIGH.

Prime the cup, fill it high ;
 Let us quaff to the fair ;
Here's—The light of her eye !
 Here's—The gloss of her hair !
Here's to one most divine,
 Though I breathe not her name ;
May her lot be with mine,
 May care ne'er find the same.
By her lip, ruby red,
 'Fill these throbs cease to move,
And each hope here lie dead,
 Her I'll love, her I'll love !
For oh ! she's all the world to me ;
 Here's—The maid I adore !
In my heart's deepest core
 Dwelleth but only she.
 Here's—The beam of her eye, &c.

She's the flower in my bower,
 She's my star of the deep ;
'Tis her form keepeth watch
 In my dreams when I sleep.
Here's to her lovely eyes,
 And to those that are thine ;
Envy not I thy prize,
 So I win only mine.
By her voice—music sweet,
 By the truth of the dove,
'Till this heart cease to beat,
 Her I'll love, her I'll love ;
For oh ! she's all the world to me ;
 Here's—The maid I adore ;
In this heart evermore
 Dwelleth she, only she.
 Here's—The beam of her eye, &c.

The earliest stock-blocks were made for individual printers to suit their particular requirements, and were passed on to their successors or sold as part of the stock-in-trade if the business changed hands. They were kept, along with decorative borders and decorated letters, for use on a wide variety of the firm's work. One of their most frequent uses was for in-filling as tailpieces or for spacing out the lettering on hand-bills, and the present-day catalogue of Stephenson Blake & Co still contains a few which are referred to as 'old style tailpieces' or 'old style engravings'.

These are reproductions of mainly nineteenth-century designs and include electrotypes of a range of Bewick blocks. The stock-block was, in fact, a development from the older practice of having blocks available for general use within individual printing offices and it is significant that its modern form dates from Bewick's time. The impetus which Bewick and his Newcastle contemporaries gave to the craft of wood engraving went a long way towards making the stock-block a reasonable proposition. The other main factor in the expansion of the use of the stock-block was the very rapid growth of trade and increase in population which occurred from the end of the eighteenth century onwards. The stock-block differs from its predecessors in that it was freely available to any printer who cared to purchase it, but the vastly increased quantity available avoided the dangers of constant repetition.

As might have been expected, the earliest examples fall mainly into two categories. The first includes such symbols of authority and majesty (used quite freely and without official sanction) as royal arms, crowns, and various heraldic and pseudo-heraldic emblems. The second was comprised of emblems denoting trades of various kinds, particularly ships and, in the early nineteenth century, subjects suitable for use in the rapidly expanding tea trade.

The catalogues of the typefounders of the time are greatly enlivened by prints of oriental gentlemen in suitable settings, Chinese buildings, tea parties and the like. So great were the demands of the tea trade that they were specially catered for by some firms who inserted advertisements such as the following in the printing trade press:

TO TEA PAPER PRINTERS. Wood engraved blocks for sale—most useful

94

Regal splendour for all occasions. From a mid-century catalogue

Stock-blocks from a catalogue

for tea paper printing (ornamental letter designs, views, &c.). Proofs post free.

or

Now ready—five sheets of entirely new and original designs for tea paper and tobacco printing. Electrotype or stereotype casts supplied to order—proofs will be forwarded on application.

The demands of packaging of various kinds, including paper bags, wrapping papers, and labels, were in part responsible for the massive growth in the number of stock-blocks produced throughout the century. An illustration of the importance of packaging is that the influence of Bewick was spread through the United States largely as the result of the work of a certain Dr Alexander Anderson, who saw some engravings by Bewick and emulated his style on a large number of paper-mill labels which he designed.

By the beginning of the last century a full range of subject matter was available direct from the typefounders' catalogues, and the specialist blockmaking firms followed soon after. The subjects which appear and the manner in which they are portrayed throw some interesting light on the attitudes and concerns of the period. Transport figures largely, and there are many delightful early blocks of horses, coaches, ships, wagons and, of course, trains. Some of these were remarkably detailed and accurate for their size but the most striking common factor is vigorous drawing and lively engraving.

The smaller examples were usually engraved and cast as type ornaments and are thus outside the scope of this book, but the others were engraved on wood and were the precursors of the commercial engravings of the latter part of the last century, when stock-blocks and individually commissioned engravings were each produced in large quantities. The size of the trade can, again, be illustrated by quoting typical advertisements, in this instance from the 1860s: 'To Proprietors of Illustrated Publications. For sale, electrotypes of upwards of 30,000 Wood Engravings'. Another firm, obviously supplying both stock-blocks and those made to order advertised: 'Wood Engraving in all its Branches, with superior Finish, Economy and Despatch, by Alfred R. Dorrington & Co. . . . Illustrated specimen book post free'. In true

97

G

Further examples from a typefounder's catalogue

Victorian fashion this advertisement contains testimonials from satisfied customers.

In 1868 John Dalziel was advertising his services as 'Draughtsman and Engraver on Wood' and continues: 'Specimens, with Terms and References, sent on application. A Gentleman who has given me permission to refer to him said—"I have had some hundreds of pounds' worth of Engraving done, but yours *is by far the best*" '. On the same page of *The Printers' Register* is an advertisement put in by another engraver which is wholly engraved on wood and, one would have thought, a very good indication of the standard offered.

Stock-blocks continued to be part of the stock-in-trade of most printers until well into the present century and the demand was supplied almost entirely by the wood engravers. Until the invention of the electrotype at about the middle of the last century even stock-blocks had to be either cast as type or cut individually on the wood, but the electrotype allowed a virtually unlimited quantity of facsimile copper printing blocks to be produced from one woodblock, and thus gave an immense boost to the block trade.

From that time the stock-block became both repeatable and more durable, and many thousands must have survived. Many of those which appear as illustrations in this book were rescued from the trays of small printers who still found an occasional use for them. The pro-

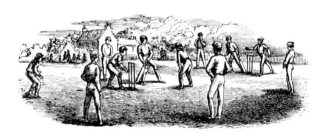

From the block trays of a jobbing printer.
Blocks purchased around the turn of the
century

cess of electrotyping is a form of electroplating. The original block is pressed into wax and a coating of copper obtained on the impression by means of an electrolytic bath. This thin copper shell is filled with metal and mounted type-high either on wood or on metal supports. Methods of casting reproductions from woodblocks had been employed before the invention of the electrotype, but the newer process was greatly superior and allowed the reproduction of much finer work.

Every conceivable need of the jobbing printer was catered for. Some traditional uses, such as the splendid cattle and sheep which appeared on butchers' bags and bill-heads can still be found, but sophistication is the enemy of the stock-block. Animals, sports, rural scenes, Britannia, floral decorations, swags of fruit, cornucopias, children, musical instruments, Masonic symbols, articles of clothing—they all appear, with many other subjects. Words such as 'Auction', 'Poetry', 'On Hire', 'Finis', 'Consigned', and others which might be considered generally useful were accompanied by suitable embellishments.

From the block trays of a jobbing printer. Blocks purchased around the turn of the century

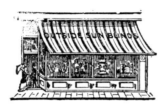

Typical stock-blocks from a jobbing printer.
The top illustration is pierced for the insertion
of type

Another common occurrence was the block pierced for type. At an appropriate place in the design a hole was cut from the block to allow the individual printer to insert a line of type. This necessitated a certain amount of 'bodging' (a habit not unknown among jobbing printers) but it worked reasonably well and was particularly useful for printing work for small traders and craftsmen. Typical pierced blocks were those showing horse-drawn pantechnicons with such words as 'Removal by Road or Rail' engraved across the front and the side pierced to allow

the printer to insert a name. Similar provision could be made for a wide variety of needs, and decorative panels were also treated in this way. The last remaining specialist stock-block firm in England finally went out of business early in the 1960s and, apart from collectors and the occasional demand for a job where a period flavour can have a special appeal, the age of the stock-block is past.

Occasionally a hunting scene may be called for for hunt notepaper, or a Bewick-type cut for an antiquarian bookseller or antique dealer, but apart from these, and the ubiquitous football, they are seldom used. One printer with a large and for many years unused stock of old blocks recently pulled a few proofs out of interest and found an unexpected use for them. A bookseller who happened to see some sheets lying around commissioned a quantity of them and found that, used as wrapping paper, they boosted his export sales to America. Perhaps it is fitting that packaging should have been in at the birth, and virtual demise, of the stock-block. For a comprehensive selection the student should visit the St Bride Institute, London, where there is a good collection both of blocks and catalogues.

An engraved advertisement from
The Printers' Register, 1868

The twentieth century: Artists' prints

THE history of wood engraving in the first half of the twentieth century has been described as a revival, but this is not strictly true. What happened was more in the nature of a change of emphasis from commercial engraving, in which the artist and the engraver were rarely the same person, to the use of the medium by artists as a direct print-making process. As we have seen, this had occurred previously in the work of such artists as Blake, Palmer and Calvert (hence, presumably, the reference to a revival), but never on the same scale as in the early twentieth century or for so many varying purposes.

There are many reasons for the apparently sudden interest taken in wood engraving by artists. The nineteenth-century private presses, particularly William Morris's Kelmscott Press, had shown that the wood-block could achieve a dignity previously unrevealed, when boldly and imaginatively used alongside type in books which were sumptuously produced and skilfully designed. Towards the end of the century the visual arts were going through a period of reaction against many of the values of the past, and in fields ranging from architecture to jewellery, costume to book illustration, there was an upsurge of re-thinking and invention. For a few brief years the arts achieved a unity unknown since the Renaissance and from this period new approaches and new

Two engravings by
Cecil Keeling

attitudes emerged which were to influence art movements for the next fifty years.

Among these influences was a new realisation of the importance of graphic design as a field of creative activity in its own right, equal in importance to painting and sculpture. This concept has been developing ever since, to a point where graphic media (including photography as well as the other printmaking processes) are often used by artists as acceptable alternatives to painting, and where graphic imagery is dominating many aspects both of painting and sculpture.

The climate in the arts towards the end of the last century was that of reaction against old ideas and ready acceptance of new concepts and new methods. In the 1890s Aubrey Beardsley was demonstrating the power of black and white illustration reproduced by photographic line-block, and these new forms must have been seen as a revelation after the years of reproductive engraving. Although Beardsley's work might have been viewed as a reaction against engraving itself, it did in fact reveal the potential of direct black and white illustration and thus pave the way for the next generation of artist-engravers who were to exploit these qualities in their own work.

Also in the 1890s there were artists at work on the Continent, both individuals and recognisable groups, whose work was fertile ground for the growth of new ideas expressed in the stark black and white terms of woodcut and wood engraving. The Norwegian Edvard Munch produced a woodcut of 'The Shriek' which brilliantly exploited the latent power of the printed surface (it is one of the most significant prints in the history of European art). At about the same time Gauguin was beginning work on his superficially crude but immensely powerful woodcuts of Tahiti. The reaction against the tedious craftsmanship of much commercial work was understandable and, once the impact of the woodcut and engraving had been demonstrated by such artists, it was only a matter of time before traditional craftsmanship was adapted to more creative purposes.

It is, perhaps, significant that as the dramatic qualities of the woodblock were being revealed on the Continent one of the first artists to use the medium for original work in England was the stage designer

Edward Gordon Craig. Craig's engravings, the earliest of which date from the turn of the century, owe a great deal to his ability to handle space, and to dispose forms and figures on a stage. His dramatic productions, very advanced for their time, frequently used sets of the utmost simplicity. Their qualities are reflected in miniature in the engravings, many of which were produced as working designs for stage sets or as decorations to theatrical programmes.

Another English artist who at the same time made engravings which were to have a lasting influence was William Nicholson. Nicholson was also associated with the stage, and worked in partnership with that highly theatrical painter James Pryde, and his engravings (which are frequently mistaken for woodcuts) also have a theatrical quality about them. His best work appears in his various books, such as the *London Alphabet* or *An Almanac of Twelve Sports*, in which the woodblocks are printed black, and broad areas of colour are added lithographically. In this Nicholson was way ahead of his time and it was not surprising that he offended some of the purists who objected to such a mixture of media.

Nicholson was also indicating a trend which was to dominate English wood engraving for nearly half a century by designing his own books and engraving the illustrations. In this country engraving has almost always been regarded as part of book design and seldom have artists produced their best prints independently of a typographic context. This is in contrast to the Continental tradition of fine printmaking for its own sake (although, of course, many French artists have also produced work for books). From the end of the nineteenth century, when Ricketts, Shannon, Sturge Moore and others were collaborating in such ventures as *The Dial*, English engraving has had strong literary associations, a tradition strengthened by memories of Blake and Bewick.

Before the outbreak of the First World War woodcuts and wood engravings had become re-established as widely accepted media for direct work by artists both in Britain and on the Continent, and prints were popular among collectors, as the larger and more colourful silk-screen prints are today. In Britain, where a greater respect for pure craftsmanship was evident than in France, the further development of

the woodcut and engraving was stimulated in various ways.

Among the most important of these were the annual exhibitions of the Royal Society of Painter-Etchers & Engravers, and the printmaking demonstrations of its offshoot, the Print Collectors' Club; the influences of the literary world; and the emphasis placed on the development of craft skills in the multitude of small and large art schools which flourished in all parts of the country and thus afforded opportunities for artists and potential artists to find outlets for their talents independently of the mainstream of artistic activity.

The RE is still the most important organisation of printmakers in Britain and its annual exhibitions offer the most comprehensive selection of current work to be seen in one place. Many of the finest printmakers working in this country over the past half century have found their first encouragement by acceptance of their prints for exhibition by the RE and most have subsequently accepted the due recognition of membership. The RE has retained its position through years of revolutionary change in the visual arts largely through its respect for fine work, whatever form it might take. It has always demanded from its exhibitors a high standard of craftsmanship as a basic pre-requisite for good work, and this has enabled it to accept into membership such widely differing engravers as Joan Hassall and Gertrude Hermes. Its influence was also felt between the wars through the teaching which many of its leading members did in schools of art.

This was very largely responsible for the unique tradition of printmaking in British schools of art which still persists, although in differing forms. The value of the disciplines of engraving was widely recognised and, for better or worse, built into the now defunct art examinations system which operated until after the last war. Since the war the RE has become increasingly catholic in its selection of work without any sacrifice of the standards for which it is respected.

Many of its members also belong to the Society of Wood Engravers, a peculiarly English society which exists with a minimum of organisation as a meeting ground for wood engravers, and a focal point of common interests. Its annual exhibitions are complementary to those of the RE and, being open to both members and non-members, are a

*Engraved illustrations by Peter Reddick to the Folio Society
edition of* The Mayor of Casterbridge *(published by the
Folio Society for its members, 1968)*

lively indication of the state of woodblock printing. Unlike the RE they are restricted to relief prints and thus give a more concentrated impression of what can be done with woodblocks. The engraving, although eclipsed in public esteem by the fashion for larger and gaudier prints, can be seen to be still very much alive.

As has already been stated, English wood engraving has always had very strong ties with book publishing and many of its finest exponents have also been writers, printers or designers of books. Lucien Pissarro, son of the impressionist painter Camille Pissarro, a close associate of Ricketts, Shannon and Sturge Moore, came to England and founded his Eragny Press at the beginning of the century. This was one of the first of the private presses to be set up by an artist largely for the production of his own works and it set a precedent which is still being followed.

The decade following the Great War saw the establishment of a number of private presses which had a tremendous influence on English art, largely through their almost exclusive use of wood engraving as a form of illustration. The St Dominic's Press had been founded in 1915 by H. D. C. Pepler but it achieved its justifiable fame through the work done for it by Eric Gill. Gill, a writer, stonecutter, draughtsman, engraver, type designer (he designed the type used in this book) and many other things besides, was, like so many English artists, a dominant influence who stood outside the mainstream of development.

In his writings he fulminated with catholic zeal against many aspects of modern society and his engravings have the same appeal to the intellect rather than to the emotions. His profound understanding of type forms (he designed two of the most important type families of the century, and wrote one of the most influential essays on the subject ever published) and his immaculate craftsmanship enabled him to demonstrate the perfect marriage between text and illustration. The sixty-four illustrations and decorations which he engraved for *The Four Gospels of the Lord Jesus Christ* published by the Golden Cockerel Press in 1931 (and for which he also designed the type) constitute one of the major works of twentieth-century book design.

The Gregynog Press, founded by two Welsh ladies in 1922, gave opportunities for a number of engravers to carry out work in condi-

Engraving by David Jones for St Dominic's Calendar, *1928*

tions conducive to fine book production, but it was to two other
presses that we owe the production of the best engraved work of the
inter-war years. These were the Golden Cockerel Press (founded 1921)
and the Nonesuch Press (1923). During its forty years of publishing, the
Golden Cockerel employed practically every English wood engraver of
distinction, and it produced its finest works under the direction of the
author-engraver Robert Gibbings. Its list of artists includes many who
were already established both as painters and as illustrators. David
Jones had worked for the St Dominic's Press before producing the
engravings for the Golden Cockerel *Chester Play of the Deluge*,
published in 1927.

Paul Nash, an artist whose works might justifiably be described as
poetry in visual form, illustrated Robert Graves's book of poems
Welchman's Hose in 1925 using wood engravings both inside and on
the patterned cover papers. Earlier than this Nash had produced his
two most original engraved works, *Places* (published by Heinemann in
1922) and *Genesis* (Nonesuch Press 1924). His only work for the Golden
Cockerel was a set of engravings for *Abd-er-Rhaman in Paradise*.

Nash produced a number of prints which are among the best
individual engravings of the period, but his best engraved work was

110

'Still Life' by Paul Nash, 1927

undoubtedly contained in *Places* and *Genesis*. *Genesis* follows the theme from darkness and confusion (the first block prints almost completely black) to light, elaboration and order in a brilliantly simple interpretation of the text. *Places* is a highly personal evocation, in words and pictures, of the essence of locality, a predominant theme in his work but never crystalised better than in this book.

His brother John also worked for the Golden Cockerel, notably his illustrations to *Flowers and Faces* by H. E. Bates (1935), but some of his best wood engravings are contained in *Poisonous Plants*, produced by the Curwen Press in 1927. The works of the brothers Nash can, perhaps, be taken as typical of the interest taken in wood engraving by English artists of the inter-war years and others, for example C. R. W. Nevinson, of the same generation could be similarly quoted. It is not the purpose of this book to compile a complete list of twentieth-century engravers, but to indicate general directions and to give an overall picture of what has happened since the demise of the trade engravers.

Probably the most important contribution to English illustration made by the Golden Cockerel Press was the work commissioned from Eric Ravilious. His first engravings for illustration were contained in an edition of Martin Armstrong's *Desert*, published by Jonathan Cape in 1926. They already display the unique decorative sense, ability to control tone and texture and to complement type which were to make Ravilious one of the best and certainly most influential engravers of his time (he was killed as a war artist in 1942).

Ravilious produced many books for the Golden Cockerel, including a monumental edition of *Twelfth Night*, but he also worked for other publishers. His greatest contribution to twentieth-century illustration is the Nonesuch Press edition of *The Writings of Gilbert White of Selborne*, produced in two superb volumes in 1938. They mark a climax in English book design and the end of an era. Since their publication no English artist has been given the opportunity to work on such a scale within the context of the printed page.

The private presses did more between the wars than give artists the opportunity to work in a medium which has proved to be so acceptable to English artists. They bridged the gap between the commercial

Illustration by John Nash to Celeste *by Stephen Hudson, published by the Blackamore Press, 1930*

printers, and 'commercial' applications of engraving, and the 'fine print' approach to engraving. The two extremes which were so apparent in the last century were brought together in a highly successful and productive marriage. A positive attempt to come to terms with the realities of increasing mechanisation and all that it implies is something which no artist can ignore, and much of the

H

history of the visual arts over the past century has been concerned in one way or another with this problem.

The nineteenth-century private press movement was largely concerned with a return to 'hand methods' as a reaction against the abuses of mass-production, and one effect of subsequent historical studies has been to overlook the good which existed in commercial printing and design generally. Twentieth-century artists have shown a growing concern for the establishment of a direct relationship between their work and the needs of society beyond the confines of the art gallery and the rare-book shop. Paul Nash was, significantly, a founder member of the Society of Industrial Artists, the premier professional association of designers for industry.

Ravilious was able to demonstrate the positive application of the work of the creative artist in various fields by producing designs for mass-production (including a very fine set of designs for Wedgwood china). As a wood engraver he was equally successful in working for the limited-edition market or for the commercial printer. His engravings still appear on the covers of pamphlets published by London Transport, and on Wisden's *Cricketers' Almanac*, and he executed work of a very high standard for a variety of such purposes, including

Engraving by Reynolds Stone, used by the Monotype Corporation in 1958 and later published by Chatto & Windus in Boxwood (21 engravings by Reynolds Stone illustrated in verse by Sylvia Townsend Warner)

Two engravings by David Gentleman (designer of many British postage stamps). Note the use of a multiple graver in both prints

calendars and covers for BBC pamphlets. He was able to prove that wood engraving is as applicable to the needs of the mid-twentieth century as it was to those of the nineteenth. Before, and shortly after, the last war, a number of publishers (notably Penguin Books) were to use wood engravings in cheap mass-produced books, but the trend since has tended to work against the engraver.

With the development of new printing techniques, particularly

recent progress in applications of photo-lithography, some of the practical advantages of wood engraving can no longer be claimed. A vast amount of printing is now done by methods which allow type and illustrations (including photographs and tonal drawings) to be laid out and photographed onto a printing plate. With such methods a print from a wood engraving has no advantage over a pen-and-wash drawing or any other form of illustration. What is more, engraving takes a great deal more time and effort than pen drawing or photography, and time equals money.

Few commercial publishers are in a position to offer an illustrator an extra fee for employing a method which has no practical advantage (although it may be aesthetically more acceptable) over cheaper means. Even for letterpress printing there are few printers who will willingly print direct from the woodblock: they prefer the electrotype or metal line-block made from the original in order to avoid any possible trouble with a now unfamiliar woodblock. It is frustrating for an engraver to spend days working on a block which he is confident will print as well as any reproduction, only to have the printer refuse to use it. He is then faced with the prospect of taking but one impression from his block, in order that a photographic reproduction can be made from it.

There is now, in Britain, a generation of engravers whose work is as good as any produced by their predecessors but who are compelled to practise as amateurs, earning a living by other means. Many teach. Others, like David Gentleman, work as designers, using wood engraving when possible and when the customer can be persuaded to allow it. Even the tradition of periodicals with a strong 'graphic' flavour seems to be in danger of expiring.

The three most interesting post-war periodicals of this nature—*Image*, *Typographica*, and *Motif*—have all ceased publication, and with them have gone some of the few remaining outlets for the engravers' work. *Motif*, in particular, accorded engraving its true place among the other arts and devoted considerable space to the work of established and promising engravers. Few engravers sell enough prints in a year to keep them in pocket-money, and even such accepted masters as the late John Buckland-Wright have found it necessary to augment their sales

116

'Fields', by Garrick Palmer

117

by working on large lino-cuts or other more superficially attractive prints.

The last ten years have seen a marked trend away from the teaching of engraving in schools of art in England, and the increasing tendency to centralise art education which is already destroying the carefully evolved structure of local provision, built up over a century, will also end a system which has enabled countless minor artists to find a congenial form of expression in wood engraving. The present position might, therefore, be interpreted as one of little hope for the future of the craft. There are, however, hopeful signs. By far the most encouraging of these is the very high standard of much of the work which is being done in spite of the unfavourable conditions. This, alone, is sufficient to guarantee survival. The artist may suffer the consequences of apathy and neglect, but the arts will survive in spite of (possibly because of) adverse circumstances.

There is also a world-wide growth of private presses—not major presses like the Golden Cockerel but small, individual printers working mostly in their limited spare time and producing works for their own satisfaction. The annual list of private press books published by the Private Libraries Association makes encouraging reading, and wood engraving still plays a prominent part in illustrating the works described. What is really needed to save the craft from reverting to a rarified form of escapism is enlightened commercial patronage. The wood engraver can provide work of a character which cannot be imitated by any other medium and which can be as suitable for the design of soup-tin labels as for the illustration of limited editions.

Throughout the whole range of printed matter there is ample opportunity for the profitable use of engraving as an alternative to commoner methods of graphic design. In the struggle to avoid the sheer monotony which is the ever-present curse of mass-production the engraver offers to the design-purchaser a well-tried alternative to universal sameness. Until suitable opportunities are offered many fine engravers will have to content themselves with producing prints for their own gratification, or running private presses as an outlet for their own works.

'Silbury Man', May 1969, by George Tute

The blockmaker

THIS chapter is included by way of a small tribute. The craft of wood engraving is dependent upon the quality of the blocks which are available for the engraver's use, and in this respect the engraver owes a great deal to the blockmaker. A new boxwood block is a beautiful object; so lovely, in fact, that many an experienced engraver has known a great reluctance to destroy its intrinsic qualities by cutting into its surface. The colour and texture of the boxwood are unique, and the production of blocks is a highly specialised business now limited, in Britain at least, to one firm. This is the family business of T. N. Lawrence & Son, which has served engravers since the great days of the commercial establishments. Many of the early blocks reproduced as illustrations to this book bear the firm's mark and were made by the grandfathᵉr of the present Mr Lawrence. Although their products are merely pieces of wood the skill and craftsmanship with which they are produced rank their makers above many so-called cabinet-makers. A well-made woodblock is a joy to own and a delight to contemplate. It has no equal, as anyone who has tried to use other woods or plastic substitutes, or to make or surface their own blocks, knows from experience.

Readers of Dickens will recall a chapter in *Little Dorrit* entitled 'Bleeding Heart Yard'. The Yard is an actual place, off Greville Street in Holborn, London, and it retains a thoroughly Dickensian character

and atmosphere. On a top floor in one corner of the Yard, up creaking flights of wooden stairs, Mr Lawrence has his workshop. It is known to practically every engraver in the country and to many from abroad and regarded by most almost as the centre of the wood engravers' world. The workshop itself—unremarkable to the casual observer—is screened from the customer's view and cut off by a counter from behind which Mr Lawrence serves a continual stream of customers. The tiny area of floor between that counter and the door must have been trodden by practically every engraver working today, and most have come to regard Mr Lawrence with considerable affection. His accumulated experience can be tapped equally by the novice fumbling with his first block or the established artist requiring attention to some specialist aspect of his craft. There can be few instances in the history of art when a supplier of materials has been held in such esteem by the artists whom he serves.

Bleeding Heart Yard is as picturesque as its name suggests. The previous premises, from which the firm was 'bombed out' during the last war, had the equally picturesque address of Red Lion Court. There is, in fact, a picturesque quality about the whole business of making and selling woodblocks which is still essentially Victorian. It is to be hoped that it may continue to survive the pressures of the mid-twentieth century.

The actual process of blockmaking appears from verbal description to be very simple, but it is this very simplicity which proves the remarkable skill of the blockmaker. In fact, Mr Lawrence reckons to train an apprentice for at least five years before he is capable of producing blocks of the standard required for engraving. It is hardly surprising that craftsmen blockmakers are rare indeed and difficult to replace.

When the wood is purchased in log form it has a high moisture content and must therefore be dried out before any use can be made of it. For this purpose it is cut into 'rounds' 1 in thick and stacked within the workshop for three to four years. The workshop cannot be centrally heated, for this causes too rapid drying and the wood will split, and the boxwood pieces are stacked in such a way as to allow a

free circulation of air around them. When seasoned, any cracks or splits which have appeared will be cut out, and the good pieces cut into rectangles and glued with hot glue into a variety of sizes. The quality of the various pieces has to be carefully matched to ensure that the finished block will engrave evenly.

The glued blocks are first planed by hand, using a wooden plane, then scraped with a flat piece of steel and finally polished with successively fine grades of glasspaper. The better the quality of the wood the finer the polish obtainable. After the polishing of the surface the thickness of the block is reduced to 'type-high' (equal to the diameter of a shilling) in a machine which was first used by Mr Lawrence's grandfather—and he started work in 1859. This remarkable piece of Victorian machinery has not only remained in continuous use for a century, but also survived the bombing of Red Lion Court. In this incident it fell from the third floor to the ground and was covered with burning wreckage before being salvaged.

After polishing and planing to type-height all that remains is for the blocks to be cut to the sizes required by individual customers. This is done, first by circular saw and side planing machine, then by hand. The absolute accuracy both of dimension and of angle is essential, particularly when blocks are to be 'locked up' with type for machine printing.

The sources of boxwood for blockmaking have varied considerably over the years. Most of the wood used in the last century came from the Caucasian mountain region. Some of the logs were of exceptionally large diameter and must have come from very ancient trees. The Russians finally ceased to export the wood from this area in 1935, when a substitute known as East London boxwood was found (named from the port which serves the district in which it is grown). This wood was of excellent quality, with some trees of large diameter, but the supply dried up after twenty-five years because of the danger of soil erosion caused by excessive felling.

The wood used today comes mostly from Venezuela and is known as West India box. It is softer than some of the others but the trees are large. A little English box is used and a supply of very hard wood from

Persia is just coming into use. It is not as large as the West India box, from which blocks of up to 6 in x 4 in can often be made as a single piece.

As a final comment on the qualities expected of a good block, and on the care with which it should be treated, the following quotation from Tomlinson's 'Cyclopaedia of Useful Arts', published in 1854 is, perhaps, adequate.

'Box-wood is the only kind that can be successfully employed in wood-engraving. . . . It should be of a clear yellow colour, as equal as possible over the whole surface, without spots or variations of tint, which mark inequality of growth and consequently of hardness, and which are sometimes quite evident in the impressions taken from such blocks, the whiter portions being softer and more absorbent of ink, and retaining it more tenaciously. The natural hardness and toughness of box, with the poisonous nature of its juices, are of great importance in preserving blocks from the attacks of insects. . . . But box-wood requires to be well-seasoned, otherwise it is liable to warp and bend. If a block of unseasoned wood be allowed to lie flat for a week or two, it is almost sure to bend upwards at the edges. Blocks of wood, therefore, should always be placed on their side edges when laid by for future use, and in the process of engraving they should be turned over on their faces, in the intervals of the work, or some degree of curvature may be given to them by the warmth of the engraver's hand.'

It is the mark of any great artist or craftsman that he conceals his skills by making them subservient to his ends where a lesser man regards them as ends in themselves. In wood engraving this is equally true, mere virtuosity having little to commend it and the work of the greatest exponents of the craft often being characterised by an apparent ease of execution and simplicity of technique. When examining the illustrations to this book, and prints in exhibitions and elsewhere, it would be interesting to make the conscious effort to consider the many skills, of blockmaker, artist, engraver and printer, which have combined to produce them and thus to arrive at a due regard, and perhaps respect, for this declining but far from moribund art and for its exponents.

'Canal Below Crofton', by Kenneth Lindley

Bibliography

Balston, Thomas. *Wood Engraving in Modern English Books.* Catalogue of an exhibition arranged for the National Book League, 1949

Beedham, R. J. *Wood Engraving.* 1921

A Memoir of Thomas Bewick. Newcastle and London, 1862

Bliss, D. P. *A History of Wood Engraving.* 1928

Dobson, Austin. *Thomas Bewick and His Pupils.* 1889

English Wood Engravers (series including books on Bewick, Stone, Gill, O'Connor, Hassall, Gibbings). 1951

Harling, Robert. *Eric Ravilious.* 1946

Hind, Arthur M. *An Introduction to a History of Woodcut.* 2 volumes. 1935

Jackson, John. *A Treatise on Wood Engraving.* 1839

Periodicals and annuals:

The Book Collector, winter 1968. Article on the Andrew Reid Collection of blocks at Newcastle University

Image, nos 1 to 8, particularly no 5: 'English Wood Engraving 1900-1950'. 1949-52

Motif, nos 1 to 13. 1958-67

Private Press Books. Published annually by the Private Libraries Association

The Studio. Various special issues

Typographica 10 (1964). Article on stock-blocks

Acknowledgments

I am indebted to the Librarian of Newcastle University and to Henry D. Davy, Managing Director of Hindson, Reid, Jordison, for permission to use material in the Andrew Reid collection. I would like to express my thanks to those artists who have allowed me to use examples of

their work as illustrations, and who have made a number of helpful comments and suggestions; also to Albert Garrett, Honorary President and Secretary of the Society of Wood Engravers, for advice and assistance. The engraving by Paul Nash is reproduced by permission of the Paul Nash Trust. The illustration from the Coalbrookdale catalogue is reproduced by permission of Allied Ironfounders Limited. Peter Reddick's engravings are from *The Mayor of Casterbridge*, published in 1968 by The Folio Society for its members. I am grateful, also, to Mr Allott, of Fletchers (Printers), Wakefield, for the loan of a collection of stock-blocks, and to Messrs Stephenson Blake & Co of Sheffield for pages from their early catalogues. Proofs of the blocks in the Newcastle University Library collection were obtained with the help of John Hopkinson, Director of the Wakefield City Art Gallery.

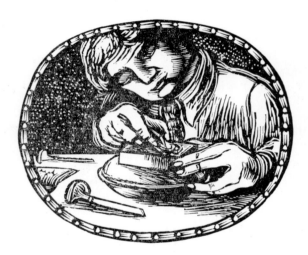

'The Woodblock Engraver' by
Kenneth Lindley

Bibliography

Balston, Thomas. *Wood Engraving in Modern English Books.* Catalogue of an exhibition arranged for the National Book League, 1949

Beedham, R. J. *Wood Engraving.* 1921

A Memoir of Thomas Bewick. Newcastle and London, 1862

Bliss, D. P. *A History of Wood Engraving.* 1928

Dobson, Austin. *Thomas Bewick and His Pupils.* 1889

English Wood Engravers (series including books on Bewick, Stone, Gill, O'Connor, Hassall, Gibbings). 1951

Harling, Robert. *Eric Ravilious.* 1946

Hind, Arthur M. *An Introduction to a History of Woodcut.* 2 volumes. 1935

Jackson, John. *A Treatise on Wood Engraving.* 1839

Periodicals and annuals:

The Book Collector, winter 1968. Article on the Andrew Reid Collection of blocks at Newcastle University

Image, nos 1 to 8, particularly no 5: 'English Wood Engraving 1900-1950'. 1949-52

Motif, nos 1 to 13. 1958-67

Private Press Books. Published annually by the Private Libraries Association

The Studio. Various special issues

Typographica 10 (1964). Article on stock-blocks

Acknowledgments

I am indebted to the Librarian of Newcastle University and to Henry D. Davy, Managing Director of Hindson, Reid, Jordison, for permission to use material in the Andrew Reid collection. I would like to express my thanks to those artists who have allowed me to use examples of

their work as illustrations, and who have made a number of helpful comments and suggestions; also to Albert Garrett, Honorary President and Secretary of the Society of Wood Engravers, for advice and assistance. The engraving by Paul Nash is reproduced by permission of the Paul Nash Trust. The illustration from the Coalbrookdale catalogue is reproduced by permission of Allied Ironfounders Limited. Peter Reddick's engravings are from *The Mayor of Casterbridge*, published in 1968 by The Folio Society for its members. I am grateful, also, to Mr Allott, of Fletchers (Printers), Wakefield, for the loan of a collection of stock-blocks, and to Messrs Stephenson Blake & Co of Sheffield for pages from their early catalogues. Proofs of the blocks in the Newcastle University Library collection were obtained with the help of John Hopkinson, Director of the Wakefield City Art Gallery.

'The Woodblock Engraver' by
Kenneth Lindley

126

Index

Illustrations are indicated by italic numerals

128

470